IMAGES
of America

CUMING COUNTY

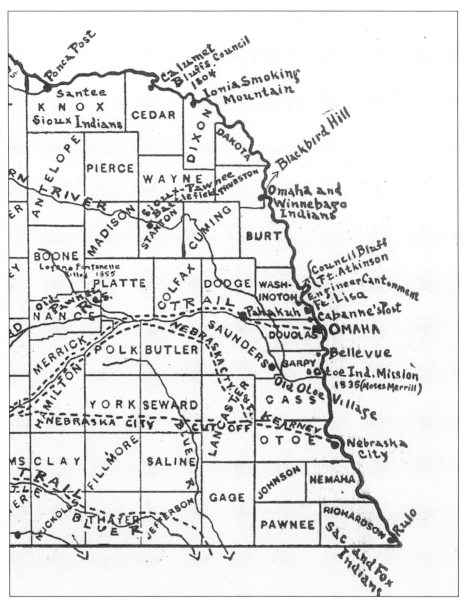

Cuming County was named after Thomas Cuming, acting governor of Nebraska Territory in the 1850s. A 1919 drawing by cartographer Martha Turner shows local landmarks, Indian villages, county divisions, overland trails, rivers, and Northeast Nebraska's larger cities. (Courtesy of Dale Topp.)

ON THE COVER: People lined up in front of Beemer's former post office to promote Red Goose Shoes, manufactured by a company founded by immigrants. Publicity stunts for Red Goose Shoes, produced in the early 1900s, were often accompanied by a large red goose, shown standing in the back row. (Courtesy of Henry Heller.)

IMAGES
of America

CUMING COUNTY

LaRayne M. Topp

ARCADIA
PUBLISHING

Copyright © 2013 by LaRayne M. Topp
ISBN 978-0-7385-9070-7

Published by Arcadia Publishing
Charleston, South Carolina

Printed in the United States of America

Library of Congress Control Number: 2012941805

For all general information, please contact Arcadia Publishing:
Telephone 843-853-2070
Fax 843-853-0044
E-mail sales@arcadiapublishing.com
For customer service and orders:
Toll-Free 1-888-313-2665

Visit us on the Internet at www.arcadiapublishing.com

To the good people of Cuming County

CONTENTS

ACKNOWLEDGMENTS

It is nearly impossible to tell the story of a county in a few hundred photographs and a few thousand words. It is completely impossible without the assistance of many, like, for example, Arcadia Publishing acquisitions editor Winnie Rodgers.

My gratitude goes out in time and space to the many amateur and professional photographers who have taken and preserved the photographs you will see in this book—photographs such as those in the Uriah Bruner collection. These photographs, which are from glass-plate negatives, are believed to have been taken by Bruner houseguest Harry Wingert, providing a snapshot of life from the 1880s through 1900s.

I am grateful for the following individuals who shared photographs from their personal collections: James Bahm, Sharlene Clatanoff, Norma Doescher, Laura Franchini, Dave Fullner, Marlene Hansen, Alice Heller, Henry Heller, Marjorie Holland, John Kaul, Dennis Kaup, Norman Kersten, Gregg Moeller, Art Nitzsche Jr., Frank Novotny, Jack Record, Fred and Terri Schneider, Vernon Schultz, Marjorie Vogt, Brian Von Seggern, Marianne Von Seggern, David Steffensmeier, JoAnn Steffensmeier, Dale Topp, and the Beemer Mennonite Church.

Chapter introductions include invaluable information from oral tapes, recorded and transcribed by volunteers and stored at the Leila Stahl Buffett Genealogy Center of the John Stahl Library. I gathered information from numerous letters, photograph albums, scrapbooks, family genealogies, newspapers, newsletters, and histories of the region, plus the anniversary volumes of each community, providing a wealth of information.

I would also like to thank individuals who shared their time and knowledge in the search for photographs and information: Joel Ernesti, representing the Elkhorn Valley Genealogy Society; Mary Jo Mack of the John Stahl Library; Gregg Moeller, representing the Wisner Heritage Museum; Wynona Behling of the Cuming County Historical Society; Sr. Mary Beth Prinz of Franciscan Care Services, and Violet Kirk and Marilyn Raabe of the *Wisner News-Chronicle*.

Finally, my deep gratitude goes to my family and friends for their encouragement, especially my number one cheerleader and proofreader, Dale Topp.

INTRODUCTION

Maybe you knew my grandmother Beata Hasenkamp. Born at the turn of the 20th century, she grew up as one of three Loewe girls in Cuming County. A woman with bright, inquisitive eyes, she enjoyed raising flowers, ducks, and apple kuchen and loved to visit. She explained to me once how her great-grandparents Ernest and Emilie (Werfel) Schlecht homesteaded in Cuming County in 1865. They burrowed a home into the Beemer bluffs, a location known today as the Indian Trails Country Club.

"My family walked all over the flat land of Cuming County and chose a place in the hills," she said.

I know why. They appreciated the view: the curve of the Elkhorn River and giant cottonwood trees shading the water, their silvery leaves noisy in a frenzied dance. Just across the way was the little settlement of Beemer, testing out its youth.

Anna Emley wrote of Cuming County land as it looked prior to 1865. There were no farm homes and fields of waving grain, nor groves of trees where the prosperous towns are now situated.

"Nothing but the rolling hills and valley covered with grasses and wild flowers, where the quail, prairie chickens and wild turkeys hid their nests. Along the river, a strip of lumber, cottonwoods, boxelder, ash, willows and wild plum trees marked the course of the stream," she wrote.

Early settlers came, not knowing who or what would greet them, like Cuming County's first settler, Benjamin Moore. Moore and his family claimed a portion of the Elkhorn Valley, building a cabin and surviving the first winter in spite of snow so deep, they had to pull hand sleds packed with supplies as horses couldn't plod through the deep snow.

They came like Augusta Heller, walking to Cuming County in 1866 when she was only 12. Her parents traveled in an ox-drawn, covered wagon to Nebraska from Wisconsin, taking an entire month to make the trip. Augusta lived on soda crackers and milk as she drove the family's sheep alongside the wagon.

Remarkably, early settlers stayed, even though winters were severe and terrible blizzards swept down over the treeless hills, causing untold suffering, according to Emley.

Luella Schwedhelm also stayed. She often told a story of her husband's grandparents who homesteaded on prairie land near Bancroft in 1867.

"They only had one room with a little hole dug in the ground under that to keep a few potatoes and things that they wanted to keep from freezing," Schwedhelm said. "Hal was the baby. Mother looked down and here Hal was on the floor, and he had a snake in his hands. A large snake. They supposed that it had crawled from the hole in the ground, crawled up between the flooring."

That might have been enough to send me packing.

Unlike Augusta and Luella, my grandmother Beata didn't stay in Cuming County. When my grandfather Edward Hasenkamp took Beata for his bride, the newly married couple moved to neighboring Stanton County, where they raised four children, a large garden, fields of ripening crops, and the expectation of prosperity.

As a second-generation product of that marriage, I too lived in Stanton County, relocating to the county of my maternal ancestry only recently, becoming acquainted with the string of Hasenkamps, Camins, Loewes, Otts, and Schlechts, and tying my lineage together. Until I made that move and began research for this book, I never knew a lot about this home.

I never knew Regina Meyer's story, whose family fought off diphtheria in the 1910s, greasing their chests with a homemade concoction that began by shooting a skunk, rendering its fat, and mixing a little bit of turpentine in with the grease.

Before I moved to Cuming County, I never heard tell of Marie Jahnke, whose family battled hoards of grasshoppers in the late 1930s that were so hungry, they devoured whole fields in a single sitting. I never knew they mixed 100 pound bags of bran with lemon oil to spread out near the fields to keep the grasshoppers fed and away from the fields and, of course, to eliminate them.

There has been a lot to learn.

Many settlers, Native Americans and more recent arrivals, original earth homes and today's versions, and paper towns and current ones are all packed into the history of Cuming County. The county we know today is no longer a treeless, grass-covered desert, but a county ripe with cornfields and soybean acres, hog cooperatives and cattle-filled feedlots, towering grain elevators and successful businesses, beautiful homes, churches, and schools.

I invite you to turn the pages, take a walk through the flatlands and river bluffs of Cuming County, and see for yourself.

One

FORMATIVE YEARS
EARLY SETTLERS CARVE HOMES

In 1871, Frantisek Chudomelka and his wife packed up their belongings and left their home in Bohemia, hoping for a better life in the New World. They traveled west to the port city of Bremen, Germany, where they boarded a steamer for America. A decade had passed since the Homestead Act had been signed, giving 160 acres of public land to any head of household to live on the land for five years. The Chudomelkas settled on land edging Cuming County, near the area that would become known as Crowell.

They erected a wooden frame house and planted grain, but the nearby Elkhorn River sent a flood over its banks onto the Chudomelkas' fields, ruining the crop. Neighbors told them that the house they painstakingly constructed would be inadequate against frigid Nebraska winds. So, Frantisek and his wife dug a cave in the hard-packed earth at the base of a large tree. They chopped the tree down so it fell over part of the hole, cut branches, and filled in the spaces between the branches with earth. They left a small opening to crawl in and out of, burrowing underground as did the gophers whose mounds dotted the plains. When winter winds blew, Indians joined them, seeking food, warmth, and shelter.

Eight years later, the Chudomelkas moved to Cuming County, to a landscape unmarked by river trees; in fact, there was not a single tree as far as the eye could see. Horses and cattle fed on wild prairie grass growing abundantly. Fish became the principle ingredient of the Chudomelkas' diet, snagged in the Elkhorn River; on a good hunting day, they ate deer, wild ducks, or geese.

One can only imagine the fortitude of early Nebraska settlers, willing to carve a home out of such raw materials to create communities, rich in the various cultures of its settlers, and grow and prosper in the land of Cuming County, Nebraska.

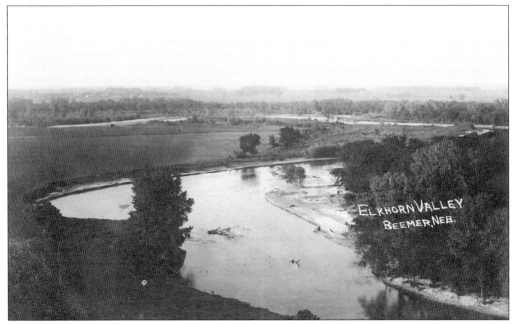

The Elkhorn River originates in the Nebraska sand hills. Explorers Lewis and Clark referred to the river as the *come de cerf*, or elk's horn. Logan Creek, named for Omaha tribal chief Logan Fontenelle, mixes its waters with the Elkhorn and Platte Rivers en route to the Missouri River. The photograph is of a peaceful, early-day scene of the Elkhorn River. (Courtesy of John Stahl Library.)

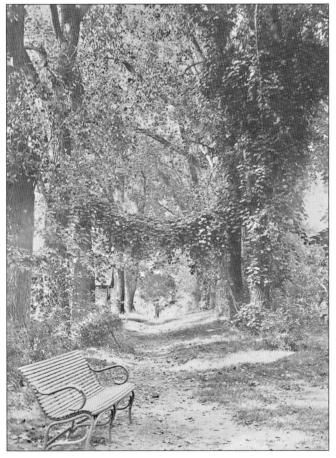

Early photographs of West Point's Neligh Park, named after John Neligh, show an idyllic scene. Called the "father of West Point," Neligh served as postmaster and mayor in the town's early years. John and Catherine Neligh's first home was a small log cabin located on the park grounds. Their son John Tecumseh Sherman Neligh developed the park and its accompanying fairgrounds. (Courtesy of John Stahl Library.)

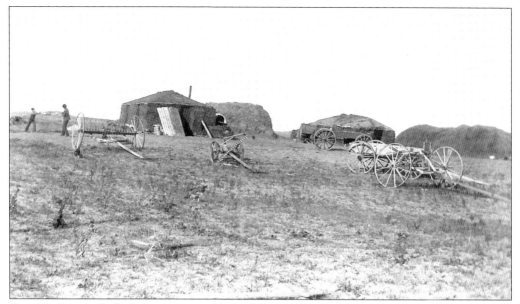

Cuming County lacked wood or stone for building material when white settlers first arrived in the area, but the tough root structure of prairie bricks held soil together well. Sod homes, such as this one west of West Point, were inexpensive to build; however, Nebraska wind and rains often worried the sod walls. Also, a family's grazing milk cow could step through the roof. (Courtesy of John Stahl Library.)

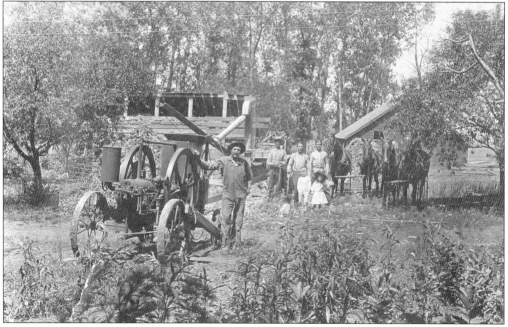

Ernest Breitkreutz homesteaded near Wisner in 1868, breaking prairie sod with a yoke of oxen and raising 800 bushels of wheat the following season. Ernest and wife Ottella endured scarcity of food, grasshoppers, and other hardships that forced other settlers to sell out. Ernest is shown in the early 1900s with a stationary gas engine powering the corn sheller in the background. (Courtesy of Marlene Hansen.)

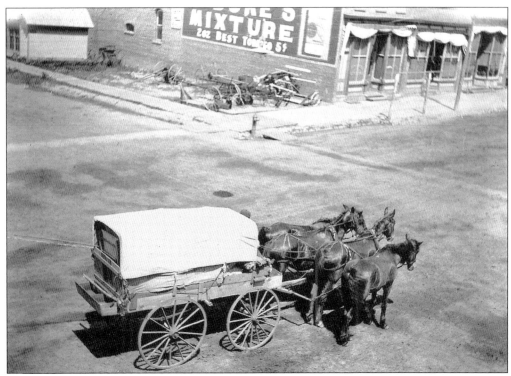

Widespread poverty in parts of Europe prompted a mass migration to the United States in the 1880s, made possible with the advent of steamships and a network of train lines. In 1892, the Federal Immigration Office opened on New York's Ellis Island, processing thousands of new immigrants daily. In 1889, this wagon pulled an immigrant family through West Point's Main Street. (Courtesy of John Stahl Library.)

Friederich Von Seggern left Germany for America in 1862. Flanked by his brothers, Fritz had this photograph taken to show cousins back home how wealthy they had become. Some Nebraska settlers purchased thick buffalo robes from American Indians and used them as rugs to stop fierce and incessant Nebraska winds from blowing up through their home's floorboards. (Courtesy of Brian Von Seggern)

The community of Wisner was surveyed and platted in the spring of 1871, with the plat filed for record in July 1871 by the Elkhorn Land and Town Lot Company. Named in honor of Judge J.P. Wisner, vice president of the Sioux City & Pacific Railway, the town was incorporated in 1873. The first town lots were sold at auction several days after the town was platted at an average cost of $129 each. The photograph above was taken on a muddy day from the top of Seventh Street, known as Nye Hill. The photograph below is an eastern view of the road leading to Wisner's cemetery, a part of the city known as Dutch Hollow. (Above, courtesy of Laura Franchini; below, courtesy of Frank Novotny.)

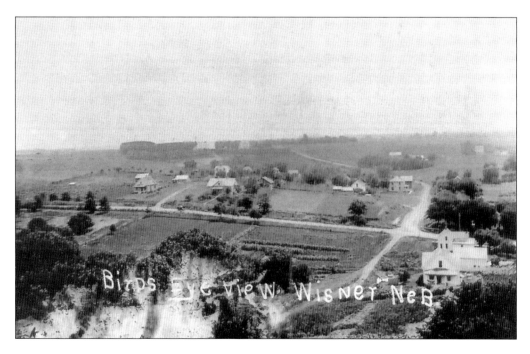

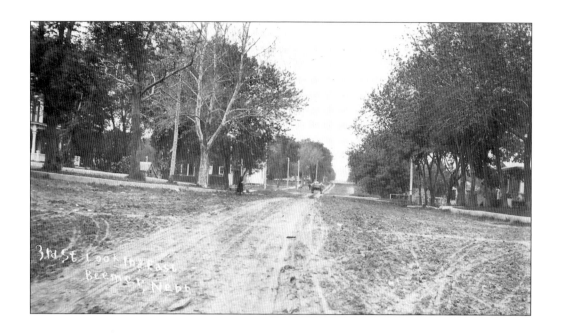

Many of the earliest settlers of Beemer Township came to the area from Wisconsin, with the earliest settler thought to be a Mr. Norris, arriving in 1864. However, by 1867, Norris had frozen to death, dealing with a harsh prairie winter. In 1869, Pennsylvanian Allen D. Beemer located in Cuming County, settling first in West Point. In May 1885, he platted the village that would come to bear his name after also filing the original plat of Beemer's predecessor, Rock Creek. From 1871 to 1876, a grasshopper plague kept the settlement from growing, but after that, it made rapid strides. The photograph above is of Third Street, looking east. The photograph below is of Beemer's Main Street, lined with Model T Fords. (Both, courtesy of Fred and Terri Schneider.)

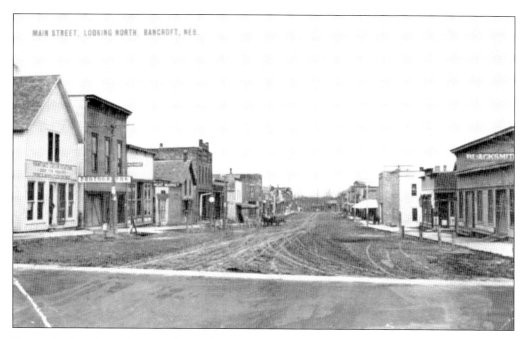

Bancroft, platted in 1880, was first called Unashta Zinga by the Omaha Indians, meaning "little stopping place," because trains stopped there for water. It was also known as Barberville for a time, as Ford Bella Barber was one of the first homesteaders in Logan Valley. Logan Creek was described as a charming stream, skirted here and there with timber. Barber bought and donated 40 acres for a townsite to the Chicago, Minneapolis & Omaha Railway, where he worked as an agent. The town, incorporated in 1884, was named in honor of historian George Bancroft. These photographs show early scenes of Bancroft's Main Street. Note the cream cans set out on the right in the photograph below and the line of telephone poles. (Above, courtesy of Marjorie Vogt; below, courtesy of Henry Heller.)

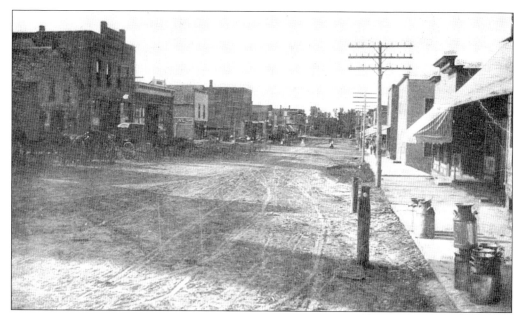

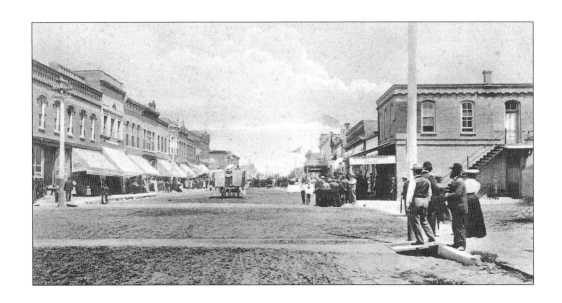

In 1857, members of the Nebraska Settlement Association toured Northeast Nebraska, traveling up the Elkhorn River and building bridges over Bell, Logan, and Cuming Creeks as they went. Once they came to a spot overlooking the wooded area that would become the location of West Point, they set down stakes. Although the site was first called New Philadelphia because a number of the association came from Pennsylvania, they finally decided on the name West Point because the area was the most westerly point to be settled in the Elkhorn River valley. In the photograph above, onlookers observe the scene on West Point's Main Street in 1909. Streetlights once ran down the center of Main Street, as shown in the photograph below. In the 1930s, they were moved street side. (Both, courtesy of John Stahl Library.)

NORTH MAIN, WEST POINT, NEBR.

Two

County Design
Boundaries Etched in Stone

An 1873 brochure promoted migration to Nebraska as follows: "The warm, rich prairies and valleys of Nebraska, ready for the plow, is a strong argument to induce Immigration, to those who are exhausting their energies in clearing forests and subduing by cultivation the hard, cold soil of the East."

The Homestead Act tempted settlers to Cuming County, competing with members of Indian nations for land. However, many Indian nations were relocated to Oklahoma Indian Territory and promised shelter, food, and housing, but in actuality, nothing, with the exception of hot winds, was offered when they got there.

In 1854, the government reserved a portion of Cuming County as a reservation for the Omaha tribe; in 1865, they were joined by the Winnebago tribe. European immigrants scrambled for the rest of the county's land, bordered on the north by Wayne and Thurston Counties, on the east by Burt County and the reservation, on the south by Dodge and Colfax Counties, and on the west by Stanton County.

West Point and DeWitt competed to serve as the county seat. A hot election ensued in 1858, and as a result, a log cabin in West Point served as the county's headquarters, even while talk went on of moving the county seat to Beemer.

Anxious to purchase land along the railroad's supposed routes, speculators dreamed up paper towns while real towns were platted only to sell the lots to eager newcomers. However, when the dust settled, four towns clearly existed to thrive in Cuming County: Bancroft, Beemer, West Point, and Wisner.

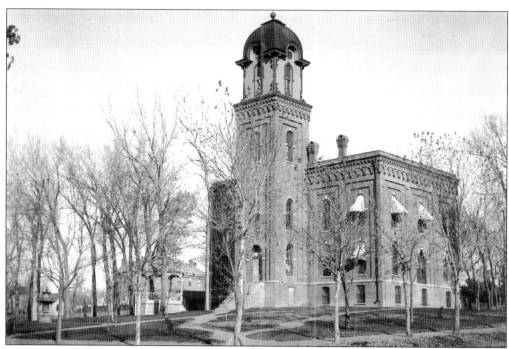

An 1872 bond election authorized construction of a courthouse in West Point. Built at a cost of $40,000, the first courthouse was completed in 1874. In the middle of construction, a tobacco pipe set the courthouse tower timbers on fire. Fortunately, the fire was easily extinguished. The 100-foot tower on the two-story building shaded the courthouse bandstand, shown on the left in the above photograph. Prominent speakers of the day utilized the bandstand, as did the West Point Cadet band for summer concerts. In later years, a fountain and fishpond on the front lawn, shown in the 1940s photograph below, kept children entertained while their parents conducted business inside the courthouse. The 1874 building was demolished in the mid-1950s upon construction of a new courthouse. (Both, courtesy of John Stahl Library.)

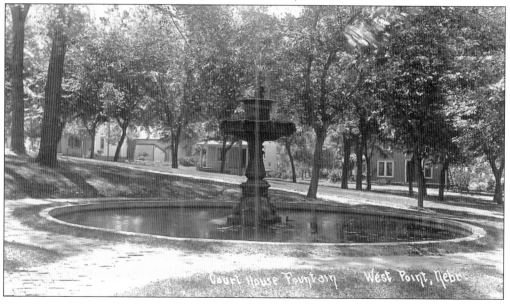

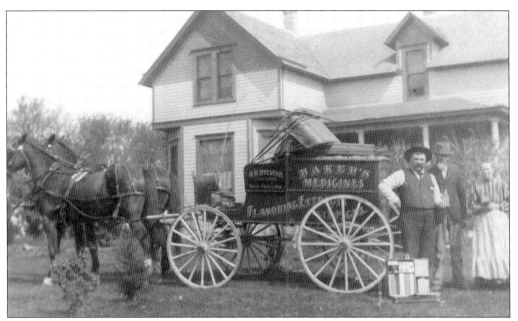

Patent medicines, concocted from cheap ingredients and claiming to grow hair, increase virility, and cure cancer, cholera, paralysis, and female complaints, were sold throughout the countryside in the early 1900s by peddlers, such as this Baker's medicine man, photographed near West Point. From Lydia E. Pinkham's vegetable compound to Dr. Kilmer's Swamp Root, these medicines came in the form of pills, potions, elixirs, and drops. (Courtesy of John Stahl Library.)

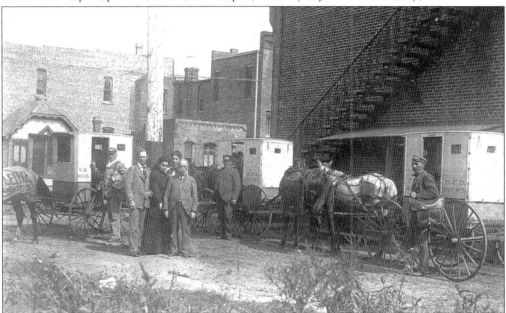

The rural free delivery mail route, via a horse-and-cart delivery system, was a convenient way to transport mail to the cigar boxes and tin cans people hastily nailed to posts at the end of their farm lanes to receive letters and packages. This horse-drawn Studebaker wagon held 26 pigeonholes, a shelf for newspapers, and space for packages and a writing table. (Courtesy of John Stahl Library.)

In the 75 years between 1854 and 1929, around 200,000 abandoned children were transported by train out of foundling homes and city streets of New York City in the hopes of finding them homes. Known as the Orphan Train, the project stopped at various locations, including Cuming County, where families taking in the children had to promise to feed and house them as they would their own. (Courtesy of John Stahl Library.)

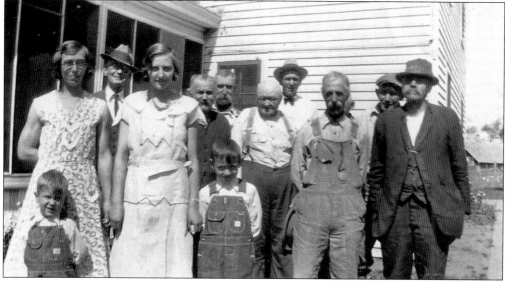

The Cuming County Poor Farm, established in 1879, was home to paupers with no job prospects or means to provide for themselves, trading their labor on the farm for a place to stay. In the 1930s, the farm was managed by Anna and Fred Kaup. Anna (far left) and young sons Dennis (left) and Harold are pictured with some of those who were offered food, shelter, and clothing. (Courtesy of Dennis Kaup.)

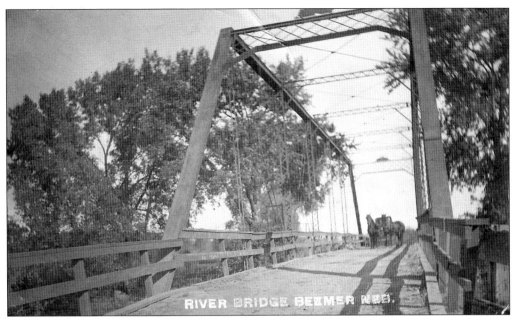

Frantisek Chudomelka settled on the Elkhorn River in 1871, using a raft to get across the river. At that time, there were no good roads or bridges over creeks or sloughs. Eventually, a network of passable roads crisscrossed the countryside, and bridges were erected, such as this one over the Elkhorn River at Beemer. (Courtesy of Fred and Terri Schneider.)

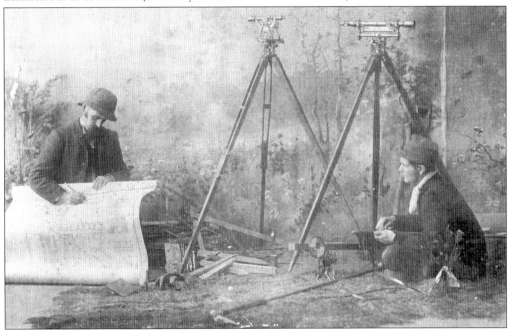

Surveyors, such as Cuming County surveyor Gus Heller, photographed here in 1892, were an important fixture in the early settlement of Nebraska. Fixing boundaries and divisions of land, surveyors were often called in to locate boundaries of property held by individuals. The transit shown was a small telescope set on a tripod, designed to measure horizontal and vertical angles and judge distances. (Courtesy of John Stahl Library.)

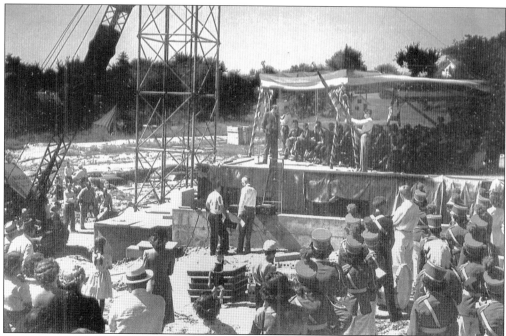

In the late 1940s, a new West Point Memorial Hospital, with space for 75 beds and 15 bassinets, was designed to replace a smaller facility. After four years of fundraising efforts, the laying of the hospital's cornerstone took place in 1949, seen above, with a blessing and dedication following in 1950. In 1964, the hospital came to be known as St. Francis Memorial Hospital. Pictured with the hospital in the below photograph is the first Guardian Angels School on the left, built in 1883. In later years, it served as a convent and boardinghouse for some of the rural students enrolled in the school. Also pictured are the new Guardian Angels School and St. Mary's Catholic Church. (Above, courtesy of John Stahl Library; below, courtesy of Franciscan Care Services.)

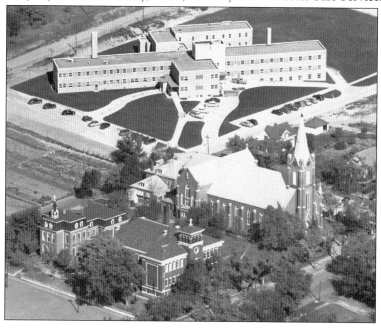

The first Cuming County Fair was held in West Point in September 1872. Although the fair was a success, other attempts in the 1870s, 1880s, and 1890s lasted just a few years. When the Cuming County Agricultural Society was founded in 1923, the fair became an annual event. An area west of Main Street was set aside as the permanent fairgrounds, as shown here. (Courtesy of John Stahl Library.)

The first territorial fair was held in Nebraska City in 1859, even before Nebraska became a state. Interested counties or communities were invited to submit bids to host the event, with Nebraska City, Brownville, Omaha, and Lincoln as sites. In 1901, Lincoln was chosen as the permanent location. This early-1900s photograph is believed to have been taken at the Lincoln State Fairgrounds. (Courtesy of Marge Holland.)

For several years in the 1940s, the local Feeders Association released 350-pound calves for teenage boys to catch, take home to fatten up, bring back, and show for ribbons. Vernon Schultz is shown in a 1947 calf scramble, having caught a calf that would later be sold to the Feeders Association and added to the menu for the Wisner Feeders banquet. (Courtesy of Vernon Schultz.)

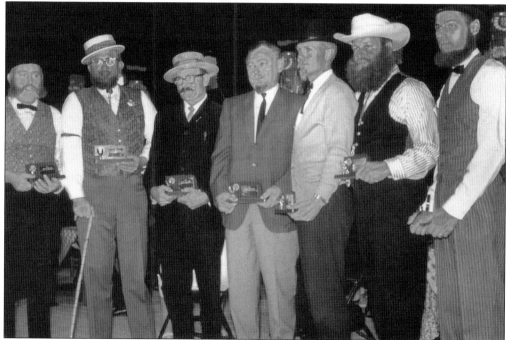

Nebraska became the 37th state of the Union in 1867. To mark the 100th anniversary of that occasion, centennial celebrations were held across the state. A beard-growing contest at the 1967 Cuming County Fair showed off such winning entries as, from left to right, the most spectacular muttonchops, miscellaneous beard, handlebar moustache, Van Dyke, goatee, full beard, and the best impersonation of Abe Lincoln. (Courtesy of Vernon Schultz.)

Three

AGRICULTURE
PLOWS BREAK SOD

When immigrants landed in Cuming County, dreams of the fields they would plant swayed through their heads like seas of grass. However, as they were soon to discover, the same thick root structure of the tough, compacted sod that made it ideal building material for dugouts and sod houses was the same thick root structure turning land into more of a cement seed bed than a receptive one.

Sod busters were used the first year on the prairie to cut and turn the sod, according to Emil Chudomelka. A sharp hatchet was then used to chop through the sod to make room for a kernel of corn. In a year or two, the overturned prairie grass roots rotted so that small grain could be planted. More sod was broken each year, so farmers eventually had grain to sell.

Cropland under cultivation increased, and so did the amount of time farmers worked their fields. Merle Martin grew up on the family farm near Beemer. He knew the work it took to get the ground ready for planting.

"At one time, we would disk twice, then you would plow and then disk twice, followed by harrowing; then you would plant and harrow again," Merle said.

As rain was said to follow the plow, so did pesky weeds. Farmers used a plow, harrow, disk, rotary hoe, spring tooth, or go-devil to be rid of them. Merle's dad planted corn in a checkerboard pattern, and Merle worked alongside his dad to keep the weeds from crowding out the corn.

"When I was a boy, we cultivated four times. We never quit cultivating; you kept cultivating until the corn got too big. We planted our corn in what they called 'check.' So, you would cultivate one way, then cultivate across ways, then cultivate long ways, and if the corn wasn't too big, you would cultivate another cross ways."

With the advent of chemicals in use on farms today, as Merle said, "All these operations are pretty much gone."

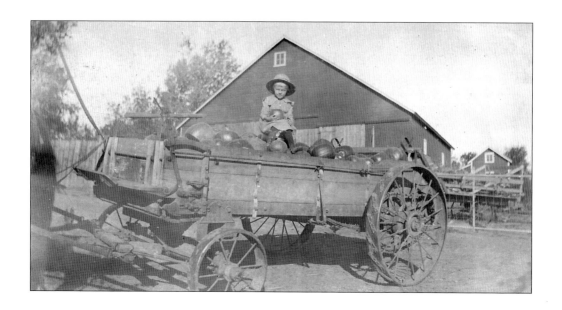

The farm was a delightful place for kids who enjoyed exploring the outdoors. There were always plants, trees, and animals growing nearly as fast as the youngsters. Eunice Bohlig, who grew up in the 1900s on a farm near Wisner, enjoyed gardening as an adult. It is no wonder that she had her start as just a young sprout, seen above seated on a pile of pumpkins. As youngsters were valuable to the farming operation, her chores included feeding spring lambs. (Both, courtesy of Art Nitzsche Jr. and Norma Doescher.)

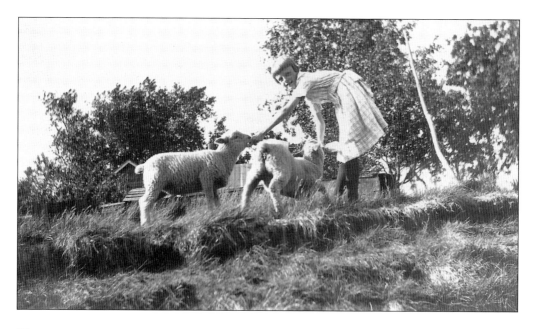

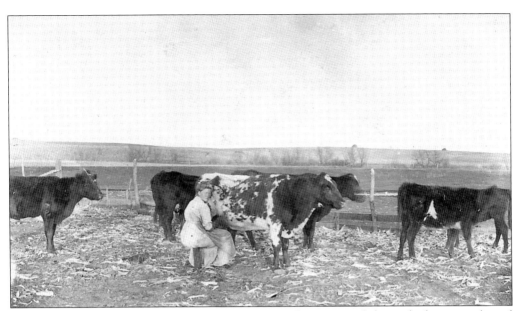

Meta (Heinemann) Topp started out her day early, milking cows while perched on a one-legged milking stool. If the cows were tame enough, they did not have to be chased into the barn, coaxed up to the manager with oats, and trapped into a stanchion with kickers clamped onto their legs. They would merely trail one another in from the pasture and stand peacefully while milked. (Courtesy of Dale Topp.)

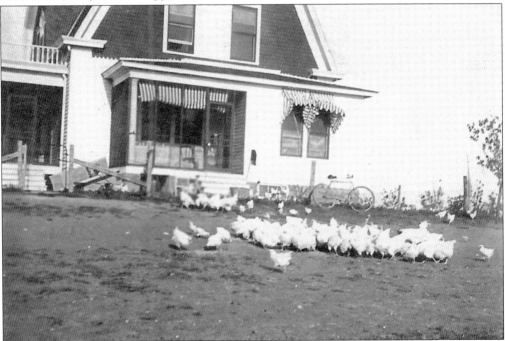

Chickens provided not only eggs for the breakfast table but also old hens for the stew pot. Excess eggs were sold, along with cream from the family cow, and traded for groceries and other household items. With four sons and husband Chris to feed, Marie Lorensen let this flock of chickens graze for grass and bugs in her front lawn during the early 1900s. (Courtesy of Laura Franchini.)

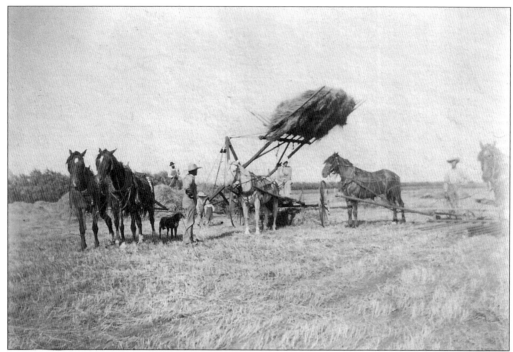

William Harder and George Schutte often put up hay near Beemer, as seen in the photograph above. After alfalfa or prairie hay was cut, it was allowed to dry, drawn into windrows via scatter rake, swept into piles before being drawn up on a Dane overshot stacker, and fashioned into haystacks. If the farmers were skillful, stacks would turn out fairly waterproof. Before the advent of tractor-drawn, hydraulics-powered stack movers, hay had to be brought in from the field on flat racks to the farmstead where it was then pitched into mangers for the cattle. In the below photograph, the child in the foreground on the Chris Lorensen farmland may have been sent out to tell the men it was time for dinner. (Above, courtesy of Sharlene Clatanoff; below, courtesy of Laura Franchini.)

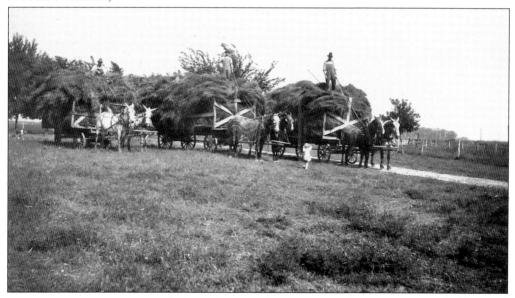

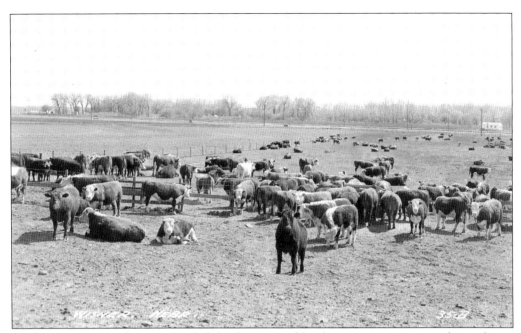

As Cuming County farms expanded, loading up and hauling corn to town in a horse-drawn wagon took much of the farmer's time. Eventually, farmers took corn to market on the hoof, driving cattle to the train station and on to market. Many cattle were fed this way; in fact, Cuming County soon became one of the largest cattle-feeding counties in the United States. (Courtesy of Jim Bahm.)

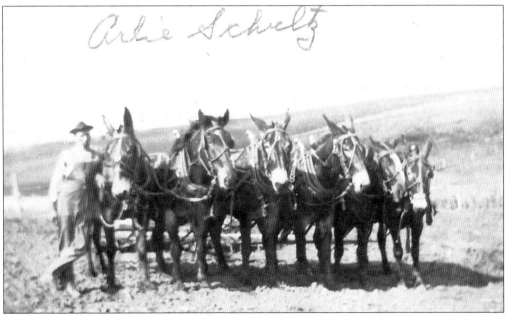

In the 1930s, some Cuming County farmers preferred mules over horses for plowing and disking. Arlie Schultz, who farmed near Beemer at that time, is shown with a six-mule hitch. He knew mules could be stubborn but believed they were sure footed and required less feed and water than horses, thus producing less manure, an additional bonus. (Courtesy of Vernon Schultz.)

29

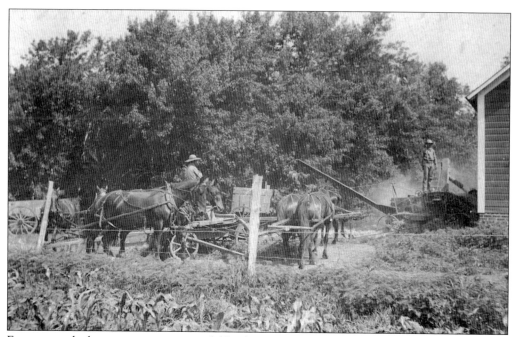

Farmers used whatever power was available, from manpower to horsepower to steam power, to harvest and process grain. An 1890 horse-powered corn sheller is in operation on the Karl Bleyhl farm north of Beemer in the photograph above. Teams of horses were tethered to and walked around a capstan, turning gears to power the sheller. A driver stood in the center to remind the horses to keep moving. The image below shows a steam tractor providing power for a stationary threshing machine on the Chris Lorensen farm near Wisner. Men pitched oat bundles into the thresher to separate the oats from the chaff. Oat straw was directed by a blower into the straw stack in the background. (Above, courtesy of Dave Fullner; below, courtesy of Laura Franchini.)

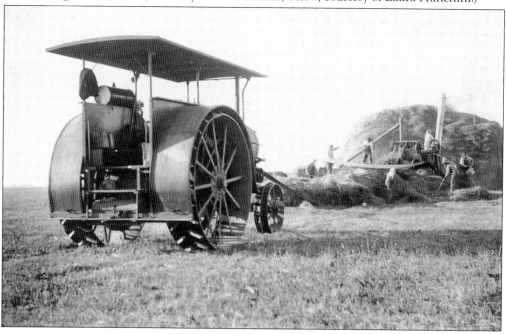

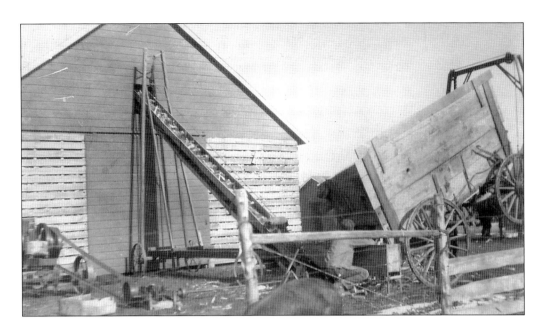

Farmers picked corn by hand, twisting ears of corn from the stalk and flinging it into a wagon; the wagon's bang board kept ears from flying over the far side. Instead of watching to see where their ear went, pickers listened for the thump. A good picker could pick 100 bushels in a day. A stationary gas engine powered an elevator to unload corn in the photograph above. A stationary hoist was used to lift the entire front of the horse-drawn wagon. Pictured below, a car is jacked up so that power could be taken from the rear axle to run the machinery. A tractor was used with a pull-type or mounted mechanical picker to elevate corn into the rubber-tired wagon. Both photographs were taken near Wisner. (Above, courtesy of Marge Holland; below, courtesy of Sharlene Clatanoff.)

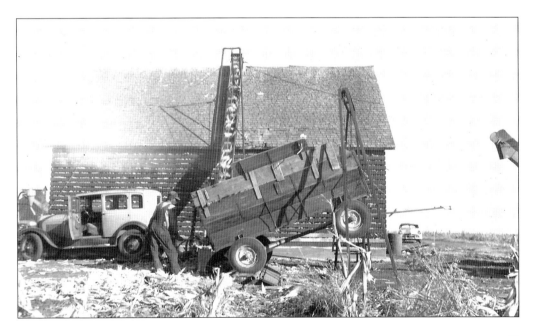

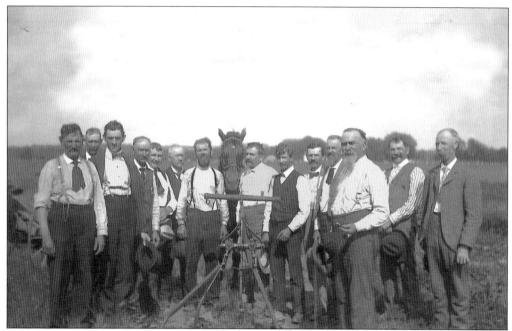

Farmers transitioned from hand-power to horse-drawn, factory-made agricultural machinery. With each new invention that came along, they widely expanded acres under tillage. Anton Psota of West Point was proud to set down his hoe and own the first-known one-horse cultivator west of the Elkhorn River. (Courtesy of John Stahl Library.)

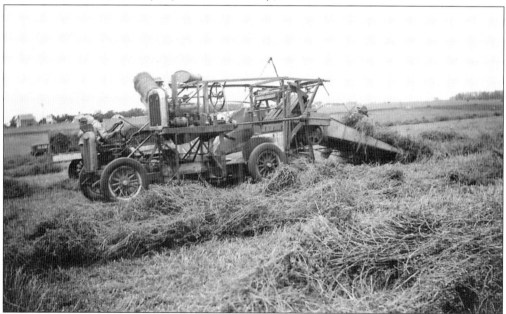

Henry Heller Sr., farming south of Wisner, mounted a Luebben round baler onto the chassis of a Dodge Brothers car to make a self-propelled baler. With one engine to drive the machinery forward and another to operate the baler, Heller was able to double the bale capacity. Round-baler designer Ummo Luebben lived with the Hellers for a time to work out the kinks. (Courtesy of Norm Kersten.)

Various agricultural operations have dotted the Cuming County landscape over the years. In the early 1910s, Chris Lorensen and sons raised livestock and farmed on their land bordering Wisner. This view looking west shows the Lorensen feed yard. Note the windmill perched on the shed roof in the center of the feedlot. In the below photograph, in a more unusual agricultural enterprise, J.F. Rosenfeld grew peonies on his farm east of West Point. In 1923, a Peony Festival Parade drew flower-covered floats down West Point's Main Street; business owners decorated store windows, and a festival queen was crowned. Local supporters hoped the parade would one day give the Rose Festival in California a run for its money. (Above, courtesy of Laura Franchini; below, courtesy of John Stahl Library.)

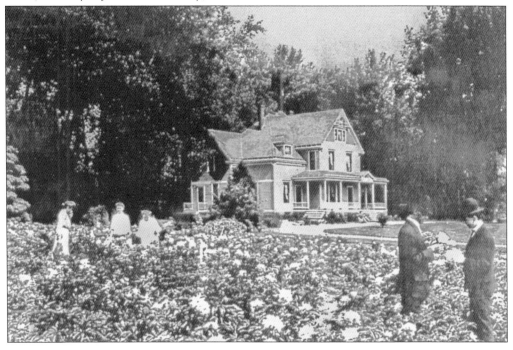

The local sale barn was a popular place for farmers, retired farmers, and wannabe farmers to set a spell. For a mere nod of the head or movement of an index finger in the direction of a quickly crying auctioneer, farmers could bid on loads of calves, single milk cows, or herds of pigs. West Point's sale barn was established by Andrew Johnson and Ed Zvacek in 1937. In later years, the building was plastered with advertisements, as shown in the photograph above. A sales pavilion, café, and filling station made up West Point Livestock Auction; also, boxing and wrestling matches were often fought there. Owner Andrew Johnson is shown below with a yoked team of oxen in front of the sale barn. (Both, courtesy of John Stahl Library.)

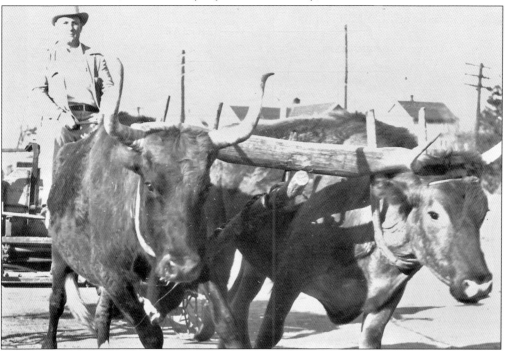

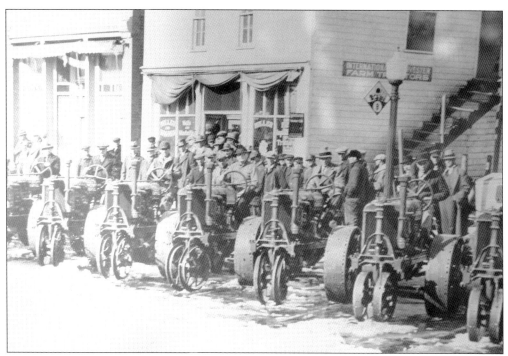

In 1929, implement dealer Hudson Miller filled a city block with a row of Farmall tractors along Old Highway 8, running through Wisner. International Harvester's new tricycle-like design, with two big wheels in the back and two small wheels in the front, was specially designed to drive through row crop fields. The design made it possible to mount cultivators on tractors or pull them along behind instead of using horse-drawn equipment. Farmers came to town, pushed back weatherworn hats, and marveled at the new equipment. In later years, rows of pickup trucks and cars lined the main streets of farming communities, as this early 1960s Beemer scene below shows. Farmers came to town to compare grain prices, rainfall, and crop yields. (Above, courtesy of Wisner Heritage Museum; below, courtesy of Fred and Terri Schneider.)

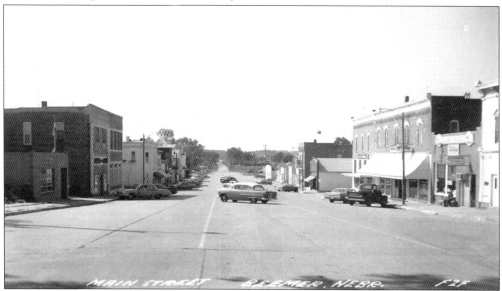

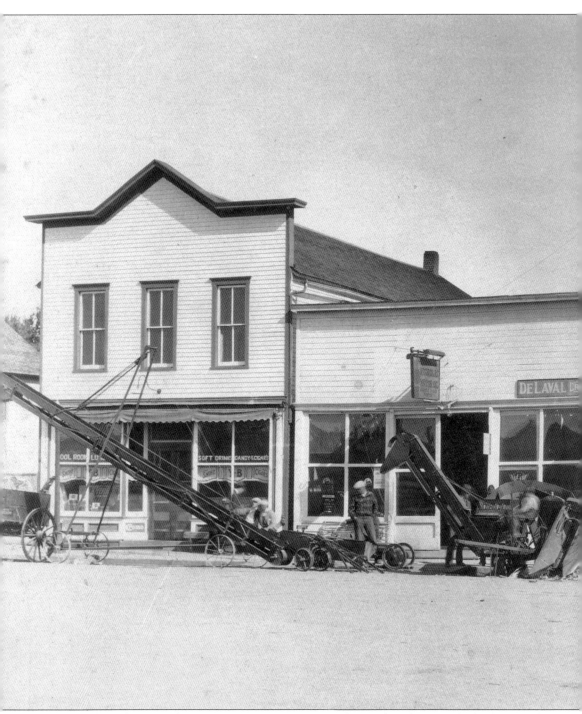

Throughout the years of Cuming County's existence, its farmers have been on the lookout for the latest in farm equipment. In 1921, modern farm implements—a wagon, elevator, one-row corn picker, tractor, and corn sheller—were displayed along Beemer's Main Street in front of a store also offering the latest in milking equipment, like DeLaval cream separators. Each advancement in machinery has cut down the number of hours required to bring a crop from planting to harvest.

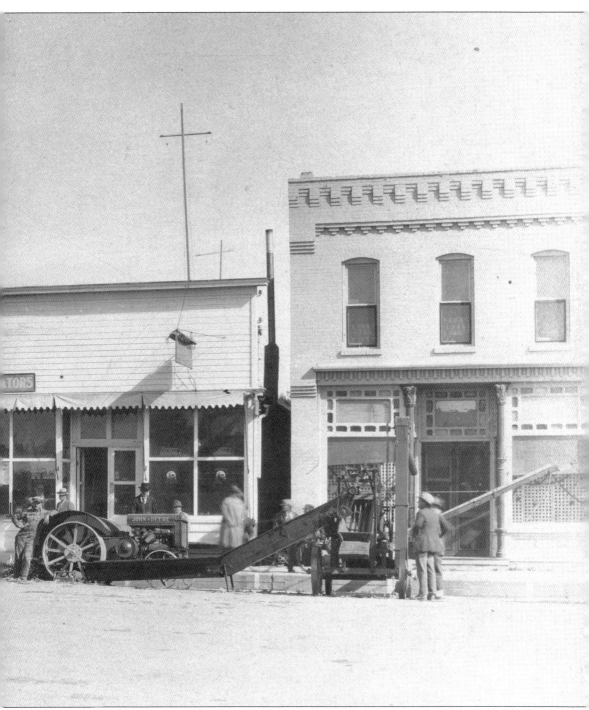

In 1850, with a horse and walking plow, it took 75 to 90 hours to produce 100 bushels of corn. By the 1980s, it took only 2.75 hours to produce the same amount with tractor, tandem disk, planter, and self-propelled combine. However, improved equipment comes with a higher price tag, requiring bountiful harvests to pay for it. (Courtesy of Sharlene Clatanoff.)

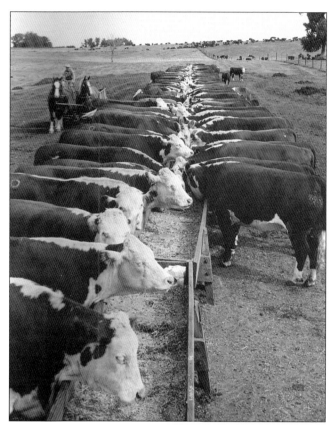

A scoop shovel was all the equipment necessary to fill feed bunks on the Louie Dinklage farm. Three hired men fed 3,500 cattle twice daily in the 1950s, scooping hay, grain, and supplement from the back of a wagon while the team of horses walked alongside the bunk on their own. This photograph of Dinklage foreman Bill Holland at work graced the front cover of the Capper's Farmer magazine in July 1957. In a less backbreaking process, Vernon Schultz used a grinder-mixer to fill a feed wagon with a ration of corn and soybean meal while feeding his cattle in the 1970s. Both cattle-feeding operations are at Wisner. (Left, courtesy of Marge Holland; below, courtesy of Vernon Schultz.)

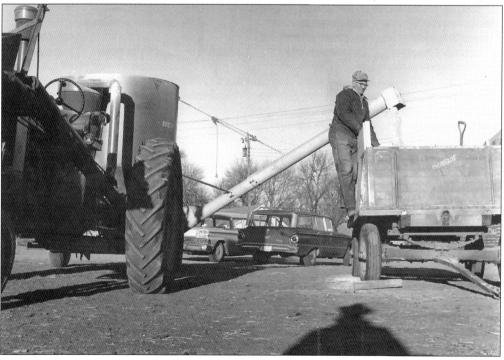

Four

MANUFACTURING
BORN OF NECESSITY

During Cuming County's infant years, settlers raised a cow for milk and butter and a flock of hens for eggs and meat. To preserve meat, they dried what they could, fried the rest, and stored it in a crock, layered in lard. They picked wild plums and grapes along the creek banks. They kept flour in a barrel and sugar in a bucket—supplies they had to travel to Omaha for by spending one day on the road, one day purchasing supplies, and one day on the return trip. Some settlers decided that instead of traveling such a far distance for what they needed, they would make it themselves. Manufacturing in Cuming County was born out of this necessity and vision.

For example, the members of the land company platting West Point put their heads and the greenbacks in their pocketbooks together and erected a steam sawmill. The enterprise was not without its problems, however. The man hired to erect the sawmill was discharged. West Point and DeWitt were both in the formations stages, and the man became an ally of DeWitt and its townsite company. Subsequently, from time to time, valuable portions of the mill ended up floating in the river. Eventually, this destruction led to out-and-out fighting. A stable was set on fire. A man was tried by a judge, and hung from a nearby oak tree.

Eventually, the sawmill was completed, as were other manufacturing enterprises, providing settlers with wheat flour and corn meal, freshly baked bread and finely brewed beer, and wooden wagons and iron clad wheels.

Today, manufacturing in Cuming County centers largely around the production of beefsteak, burger, and beef roasts. The many feedlots throughout the county finish out so many head of cattle; in fact, the ratio of cattle to people runs about 20 to one.

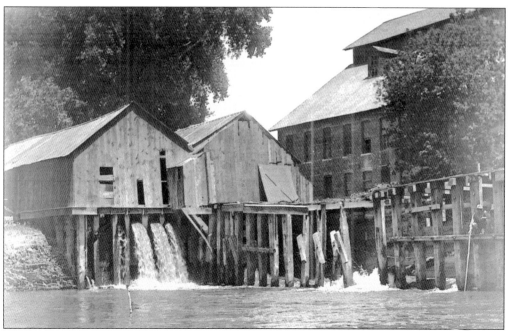

Equipped with one set of burrs, Bruner, Neligh and Company built a gristmill near West Point and started grinding grain in April 1868. Eventually, another run of stones was added, and in 1890, the mill was converted to a roller mill. With the Elkhorn River furnishing waterpower, the mill had a daily capacity of 150 barrels of flour. (Courtesy of John Stahl Library.)

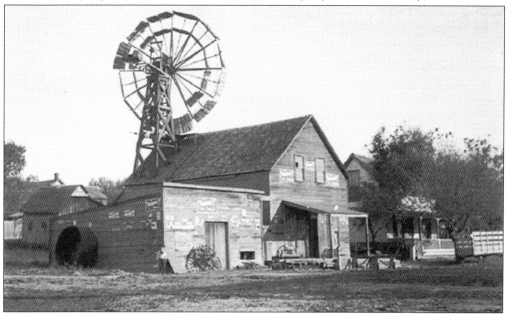

Early immigrants brought with them the Old World technology of windmills. The windmill situated atop the Niles Larsen Wagon Shop in West Point was connected to a power shaft in the shop, furnishing power for the belt-driven machinery and tools used in the manufacture of wooden wagons. The shop's owner, Niles Larsen, is pictured to the left of the shop. (Courtesy of John Stahl Library.)

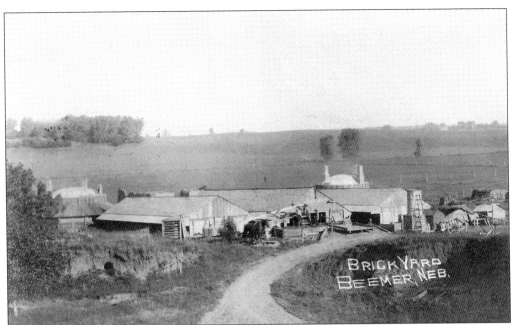

The Beemer Brick Company began in 1891 with a horse-powered brick machine. Brick sand was dug from the hillside, resulting in the Beemer hole, an area the size of a city block and 40 feet deep in places. After the bricks dried, they were baked in firing kilns: round buildings with firing pots and steady fire to bake the bricks to a hard finish. (Courtesy of Fred and Terri Schneider.)

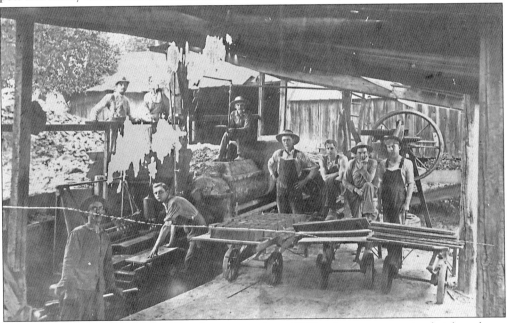

Bricks were manufactured in West Point as early as 1878, when an extensive brickyard was established there, turning out one million bricks during the first summer. The industry grew, and by 1902, West Point Brickyard workers were able to make 28,000 bricks daily, dried on three drying kilns. The brickyard was located near the present site of the Cuming County Fairgrounds. (Courtesy of John Stahl Library.)

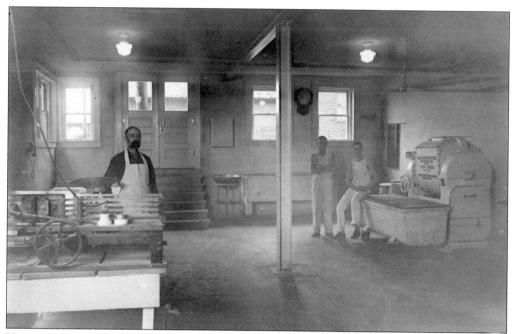

Henry Baehr and his family operated a bakery in Wisner for 68 years, beginning in 1906. They built a new brick building in 1926. In 1927, they began baking and selling White Bear Bread, which featured three polar bears on an iceberg on the wrapper. Henry's son Paul, famous for his prune rolls and other baked goods, took over in 1950. (Courtesy of Wisner Heritage Museum.)

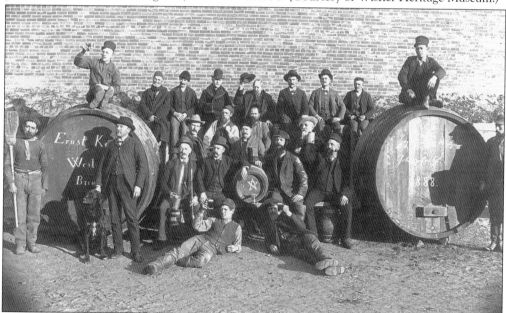

In 1869, when the West Point Brewery went up, 14 saloons in town helped wet citizens' whistles. Teams of horses hauled beer wagons throughout Cuming and adjoining counties under the threat of Prohibition's strict laws to the contrary. The brewery held a capacity of 5,000 barrels a year, with local farmers purchasing hops leftover from the brewing process for cattle feed. (Courtesy of John Stahl Library.)

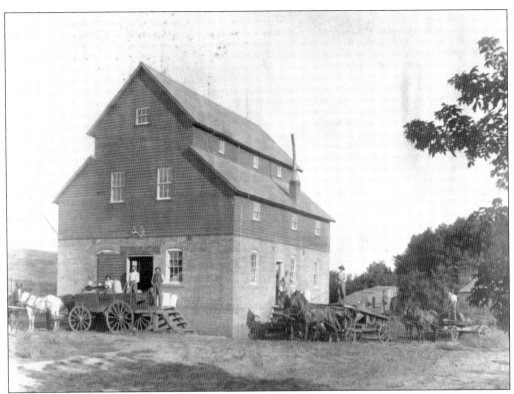

In 1870, Henry Lambrecht built a gristmill on the Rock Creek, damming the creek to supply waterpower. Because the creek did not freeze during the winter, the mill could run year-round. According to some reports, the mill had a daily capacity of 120 bushels and was the only mill in existence north of Omaha. Flour was shipped to Omaha and Kansas City, as well as local markets. By 1891, Beemer became well established on the north side of the Elkhorn River, and the people of the community offered Henry's son August Lambrecht $1,200 to move the mill to the north side of the river. This new mill was first powered by a steam generator and manned by mill workers, pictured right. (Above, courtesy of Henry Heller; right, courtesy of Cuming County Historical Society.)

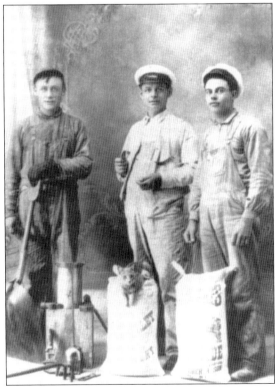

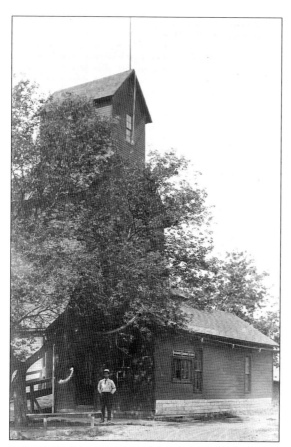

Bookkeeper Philip Baas stands in front of Fried's Elevator in 1910, conveniently located north of the railroad tracks in Beemer. The business began as a lumberyard and grain elevator, established by J.L. Baker, later bought out by W.T. Fried. Similar to other elevators of its time, the business also handled coal and other supplies. (Courtesy of Sharlene Clatanoff.)

Agricultural cooperatives have been valuable industries in farming communities. By taking advantage of volume discounts, coops bring down the costs of seed, fertilizers, and chemicals, plus offer a better market price when farmers pool their crops to sell. These bins, pictured in the 1970s, stored grain successively for Bancroft's Farmers Union, Farmers Coop, Agland, and Central Valley Ag; they remain in use today. (Courtesy of Marjorie Vogt.)

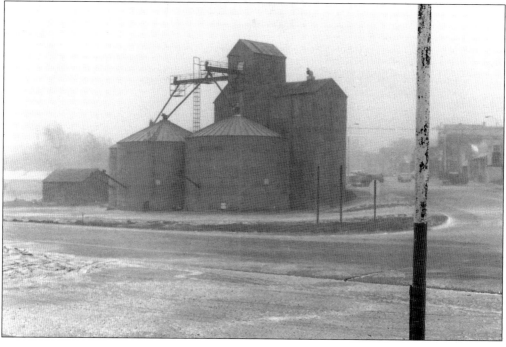

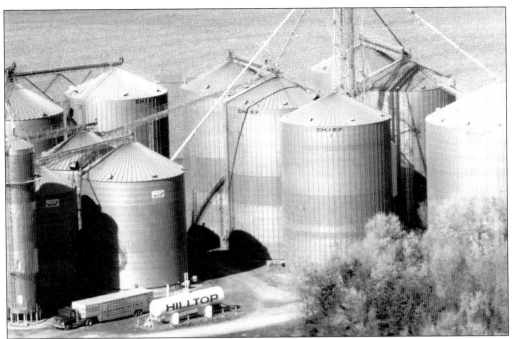

Hilltop Feed and Grain, located north of Beemer, was established in 1974. Four shareholders incorporated the company in 1973, as the need for a grind-and-mix feed operation was evident. Along with grain storage and corn-drying equipment, animal health products and a complete line of hog and cattle feed were added as the company grew. (Courtesy of Cuming County Historical Society.)

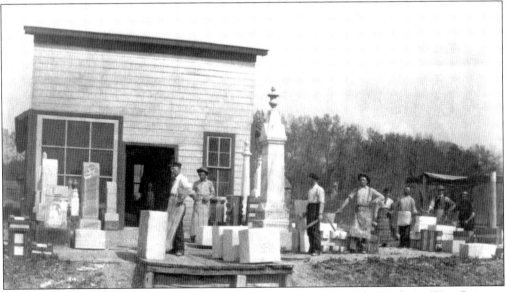

Frank and Rose Alderman founded West Point Granite and Marble Works in West Point in 1887. Joe Wostoupal Jr., an Alderman apprentice, purchased the business in 1900. A member of the Wostoupal family ran it until 1984, when Earl and Mary Boston renamed the business West Point Monument upon its purchase. The photograph depicts monument workers in 1910. (Courtesy of John Stahl Library.)

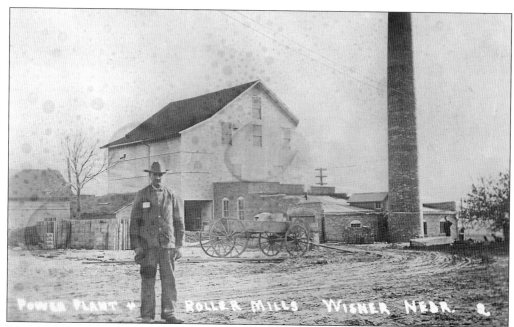

F.B. Van Dorn erected Wisner's roller mills in 1886 with a daily capacity of 75 barrels of flour. By 1924, the mill supplied all of the electricity for the town. The city's lights were typically shut off at midnight, unless everyone was having a good time at a dance and did not want it to end. Then the hat was then passed, and the money contributed kept the plant running and the lights on. By the 1930s, the electrical switchboard, shown in the photograph below, ran the city's electrical service, powered by a diesel plant with city employee Harry Teebken at the switch. (Above, courtesy of Marge Holland; below, courtesy of Wisner Heritage Museum.)

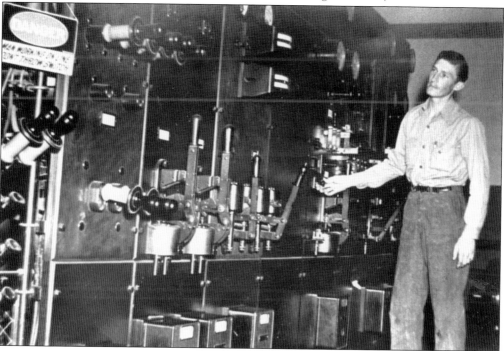

Five

COMMERCE
BUSINESSES FLOURISH

Cuming County was a fast bloomer. In 1860, for example, only 67 brave settlers had planted themselves within county limits. By 1880, only 20 years later, that number had blossomed to 5,573. As towns flourished and farms grew in size, so did manufacturing. Even so, residents began to clamor for items that could not be manufactured by one of their own. Retail businesses, the next branch of commerce to sprout, began to leaf out up and down the main streets of Cuming County. Goods were brought to town by railroad boxcar, overland freight, or an independent hauler. Although some items, such as wheat flour and bricks, were made locally, many other items were brought in for sale.

As the state's settlement moved east to west, the land office for filing homestead claims relocated from Omaha to West Point. In 1868, only a dozen buildings made up West Point's business district. But only two years later, the railroad was complete, and 150 homes and businesses lined the streets of West Point. Businesses in town included a harness shop, furniture store, gristmill, sawmill, brewery, brickyard, a bank, a millinery, two meat markets, two wagon shops, three hotels, three attorneys, three boot-and-shoe stores, three blacksmith shops, four doctors, four groceries, five general stores, and seven land agents. One resident minister was recorded.

Over the years, Cuming County residents have shopped locally, ordered items through the Sears and Roebuck catalog, trekked to bigger markets in Omaha, Sioux City, or Norfolk, ordered it over the Internet, made it themselves, made do, or did without.

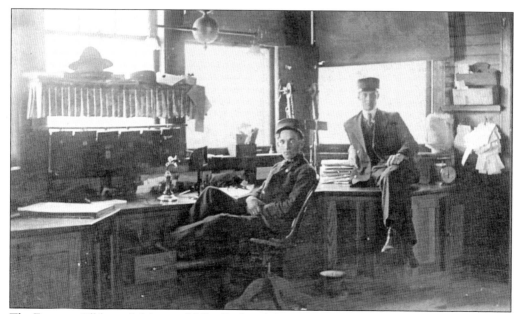

The Fremont, Elkhorn & Missouri Valley Railroad Company was established in Nebraska in 1869. Construction of the new railroad line commenced that year, with tracks laid to about 10 miles north of Fremont. By 1870, the tracks extended to West Point. Eventually, the railroad offered access to Omaha markets in four states, along with convenient passenger service. The company constructed several lines in Nebraska, including a long east-to-west route from Omaha across northern Nebraska known as the Cowboy Line. The West Point depot, pictured above, shows several of its agents. Reports say the agents of the Beemer depot, shown in the photograph below, may have been taking a coffee break. (Above, courtesy of John Stahl Library; below, courtesy of Cuming County Historical Society.)

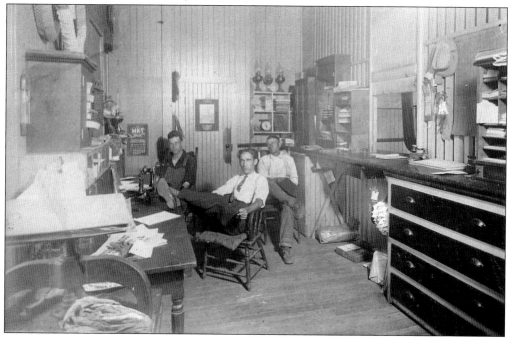

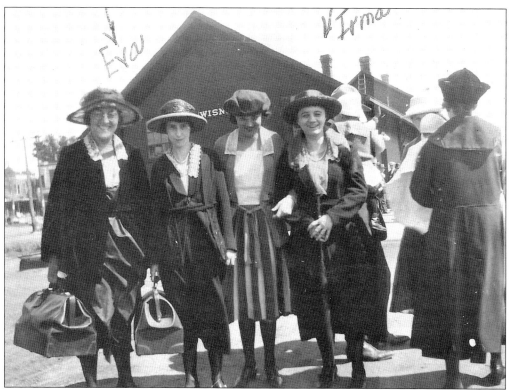

By 1871, the tracks of the Fremont, Elkhorn & Missouri Valley Railroad had extended to Wisner, remaining the end of the line until 1879. The roundhouse used to repair and switch locomotives was located in Wisner, with the line ending several miles west of town. Eva (Wallace) Stewart and Irma Wallace, identified on the image, are seen waiting with friends to board a train at the Wisner depot in the early 1900s. (Courtesy of Marge Holland.)

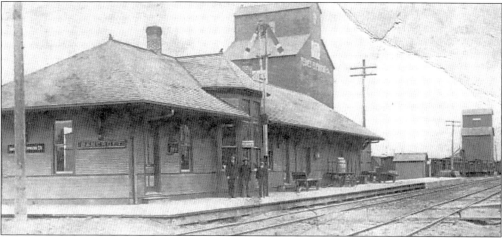

The Chicago, St. Paul, Minneapolis & Omaha Railroad capitalized on the demand for transportation, bringing in eager settlers to the newly developing state. Rail lines passed through Bancroft in 1880. At that time, a little over seven miles of track had been laid in Cuming County. The Bancroft depot is pictured in the front, with the Farmers Elevator in the background. (Courtesy of Cuming County Historical Society.)

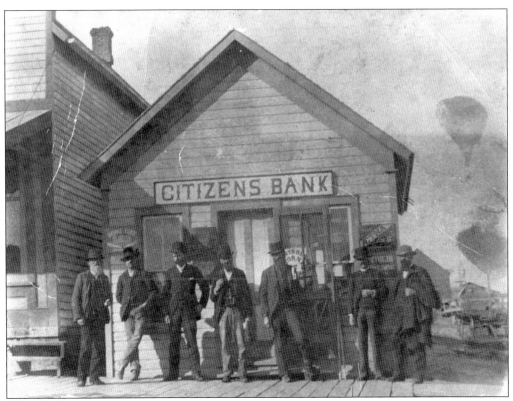

Citizens Bank, incorporated in 1891, was the second bank to open in Bancroft. The bank began doing business in a small-frame real estate office, successful enough to construct a new building in 1893. The board of directors, pictured here, included Bancroft's founder F.B. Barber (far right). Only one person in the group had any banking experience. (Courtesy of Cuming County Historical Society.)

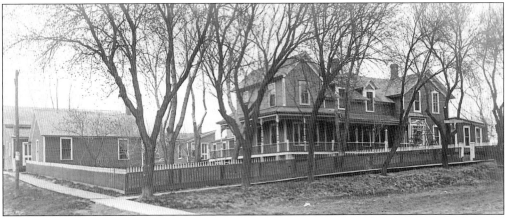

Built by the Fletcher family in 1893, the Ideal Hotel was one of four hotels in Bancroft in the late 1800s. By 1897, the hotel was so popular that five of the hotel's rigs were kept busy delivering travelers from the train. The two-story building held 13 sleeping rooms and two apartments, with a dining room large enough to accommodate 40 guests. (Courtesy of Henry Heller.)

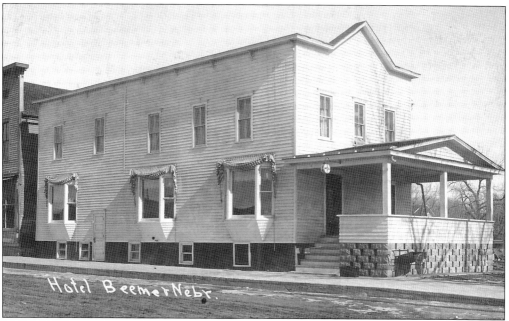

The Beemer hotel was built in 1890. Numerous overhanging trees shaded townspeople who visited on its front porch. In 1913, a lightning strike and resulting fire extensively damaged the structure. At that time, the building was remodeled, the porch was removed, and a basement was constructed beneath. The hotel was replaced in the mid-1960s by Beemer's present motel. (Courtesy of Fred and Terri Schneider.)

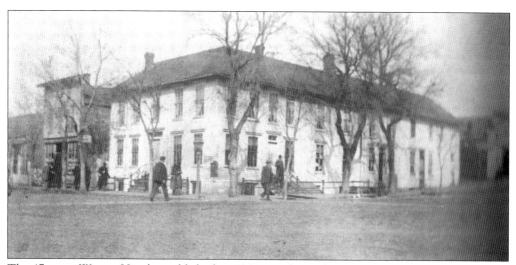

The 17-room Wisner Hotel, established in 1869, was located on the north side of Main Street. A two-story hotel, the structure was built to accommodate a possible third floor. In its 92-year history, the hotel was the social center of Wisner, housing a restaurant with a reputation for good food, a saloon in the basement, and other small businesses. (Courtesy of Vernon Schultz.)

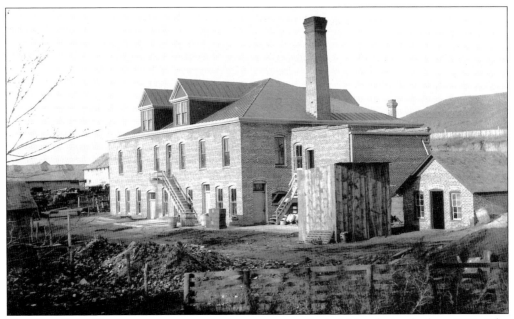

The West Point Creamery was among the largest creameries in Nebraska in the late 1800s. The business produced around 360,000 pounds of butter each year, selling and shipping it to Omaha markets. The company grazed its dairy cows on many acres of land around West Point. (Courtesy of John Stahl Library.)

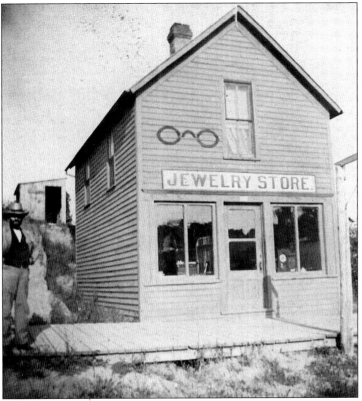

Beemer businessman William Hille purchased this building in 1890, adding a pair of spectacles near the second-floor window and a jeweler's sign below. Customers could get their watches cleaned and repaired while purchasing clocks, jewelry, silverware, china, stationery, and small musical instruments. Hille may have used this photograph as an advertisement for a 1911 cookbook. (Courtesy of Sharlene Clatanoff.)

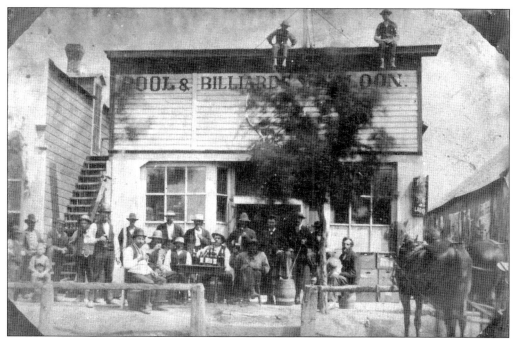

Schauman's Saloon offered pool and billiards as entertainment, as this tintype image, taken in the late 1880s or early 1900s, shows. Frederich Kaul and sons Frank and Fred parked their horses and buggy at the back door of the saloon—just across the street from the Wisner railroad depot—and took tables, chairs, and a keg of beer outside. (Courtesy of Alice Heller and John Kaul.)

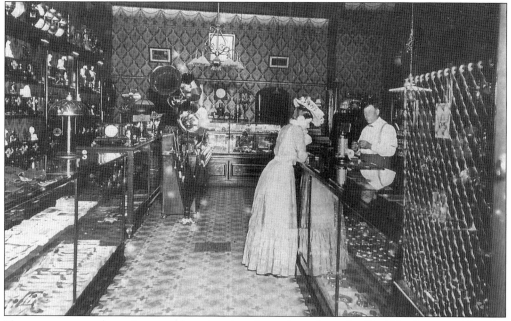

Here, a customer shops for possibly a ring, hatpin, or brooch at the Kerl Hardware and Jewelry Store, located on West Point's Main Street. Martin Kerl first operated a hardware business there in 1908 and later purchased a jewelry store in 1911, which his sons operated. (Courtesy of John Stahl Library.)

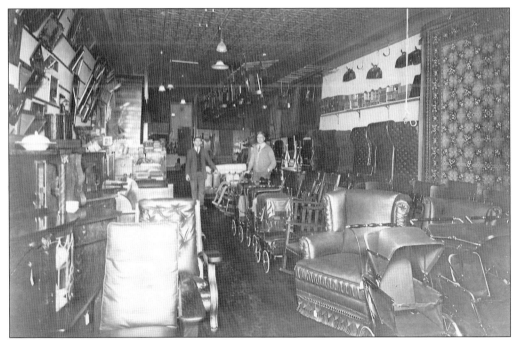

Beemer businessman Joseph A. Shores is pictured in both of these photographs. Above, he is shown running a combination funeral parlor and furniture store, located on the south side of the Shores Building. Below, he is pictured in his hardware store on the north half of the building. A freight elevator in the back of the store gave customers access to the second floor where caskets were stored. In earlier times, owners of funeral parlors often built caskets. The leftover wood and the undertaker's spare time were put to good use in the making of and selling of furniture for the home. (Both, courtesy of Sharlene Clatanoff.)

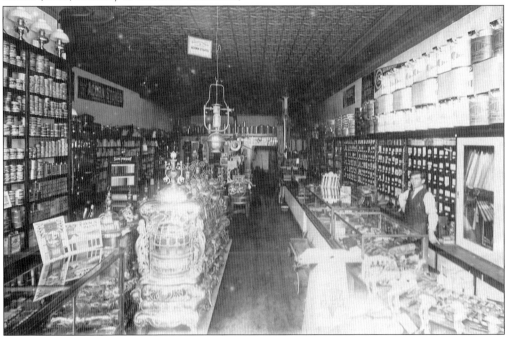

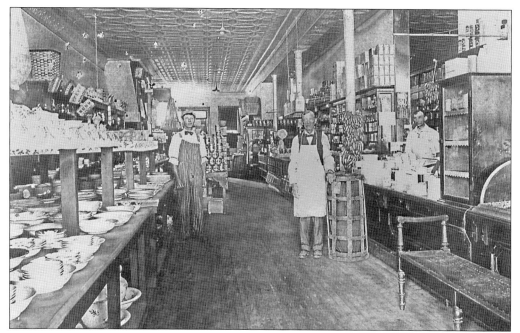

The Baumann Store supplied the residents of West Point with a variety of goods and services, as this 1912 photograph shows. The first floor sold clothing and shoes, as well as feed, groceries, appliances, and toys. On the second floor, a beauty shop kept women's hair stylishly coiffed, and store personnel offered classes in hairdressing and dressmaking. (Courtesy of John Stahl Library.)

Built as a private residence by Beemer's founder, A.D. Beemer, this house has served in various capacities. In the 1950s through the early 1970s, Martha Schantz ran Pleasant Haven Rest Home, an 18-bed nursing home there. Later, the house was used as a tearoom and is now a private residence once again. (Courtesy of Sharlene Clatanoff.)

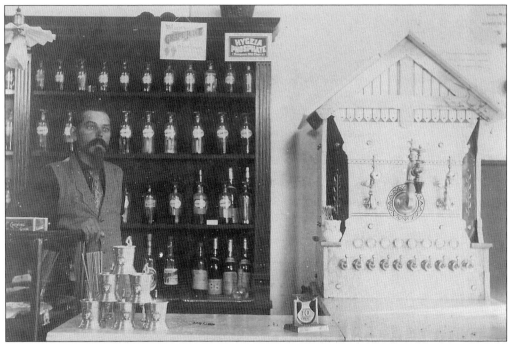

Hudson Bruner, pictured here, was a pharmacist in the Thompson Drugstore. John Thompson built two drugstores in West Point; the second one was built after the damaging flood of 1891 left several feet of water on Main Street. John moved to town when he was 15. He left to attend business college, returning to buy the drugstore in partnership with his brother Dr. Thomas Thompson. (Courtesy of John Stahl Library.)

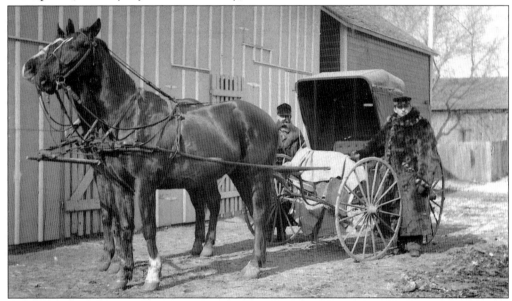

A doctor making house calls was a common sight in horse-and-buggy days. Dr. Thomas Thompson owned one of the first carriages the West Point area, which he used to call on the sick. Dr. Thompson, the first doctor in West Point to perform major surgery (left) is shown in the 1980s with his driver, Theodore Rasmus. (Courtesy of John Stahl Library.)

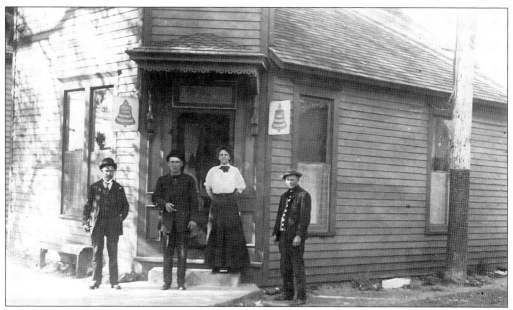

One of the first telephones installed in Cuming County was strung from Thompson's Drugstore in West Point to the pharmacist's home. With the popularity of such easy communication, the Nebraska Telephone Company opened an exchange in West Point in 1898. Bills were sent out with a fee of $2 a month for businesses and $1.50 for residences. By 1910, the large number of subscribers called for an expanded workforce. Telephone operators were called "Hello Girls;" they often rang the noon whistle or sounded the fire alarm. Each patron shared a line with a number of neighbors. A combination of long and/or short rings told each patron when it was his or her call; however, anyone could pick up the receiver and listen in on the conversation. This was called rubbernecking. (Both, courtesy of John Stahl Library.)

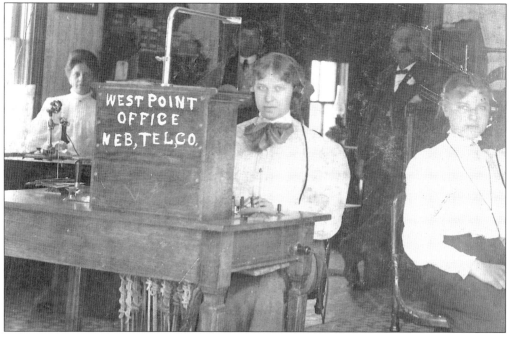

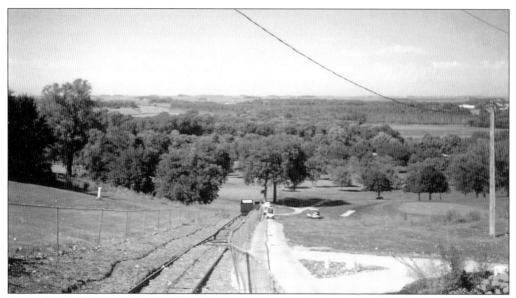

Indian Trails Country Club, south of Beemer, was named after the paths Omaha Indians often took to visit an early-day Lutheran minister living west of the driving range. Because of the steep nature of a portion of the golf course, the club was one of the few to feature a tram, which elevated people to the top of Cardiac Hill with the push of a button. (Courtesy of JoAnn Steffensmeier.)

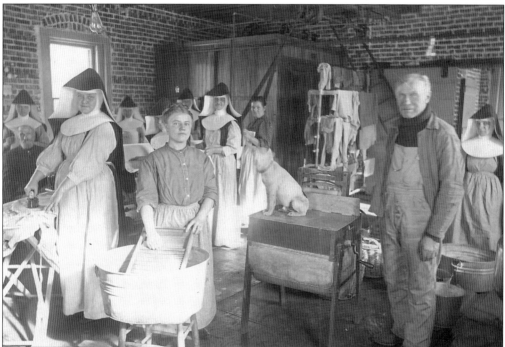

St. Joseph's Home for the Aged was established in 1905 in a private residence. Four Franciscan sisters of Christian Charity provided care, with the priest from St. Mary's Catholic Church as the administrator. In 1907, a four-story brick structure was added, and orphans were also admitted. Some of the younger residents worked alongside the sisters, completing together the task of washing and ironing clothes. (Courtesy of Franciscan Care Services.)

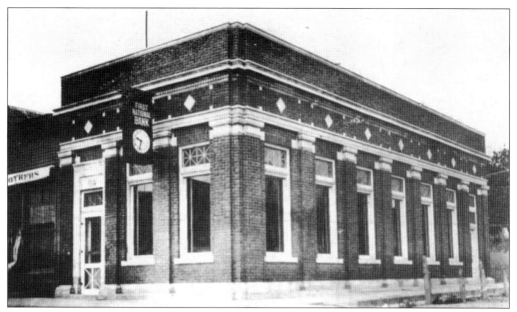

The First National Bank of Beemer was originally known as the Farmers State Bank of Beemer. Organized in 1899, its first president was Gottfried Karlen. Beemer's Karlen Memorial Library is named in honor of Karlen and his wife. The late Raymond Steffensmeier was named president in 1964. (Courtesy of David Steffensmeier.)

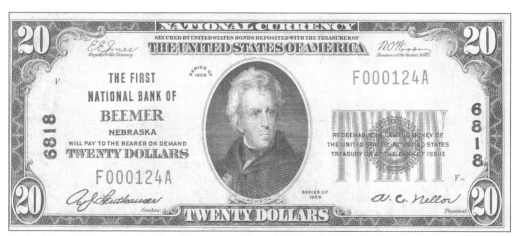

In the United States, the free banking era ran from 1837 until 1866. At that time, private currency was in popular use, issued by private banks, railroads, construction companies, stores, restaurants, and even churches and individuals. If the issuer went bankrupt, the note was useless. Fortunately for people who banked at the First National Bank of Beemer, its private currency was credible. (Courtesy of Fred and Terri Schneider.)

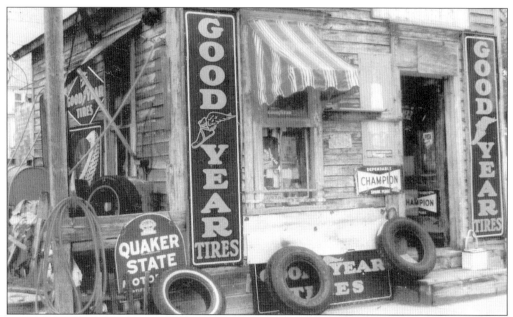

Phil Connaughton's tire shop was a well-known business along Wisner's Main Street and possibly the most photographed feature of the town. Before settling in Wisner, Connaughton worked as a ranch hand, coal miner, field hand, mail carrier, and tree bark peeler. Beginning in 1925, he studied and taught tire repair at the Goodyear Plant in Akron, Ohio. Following the lead of his father who ran a shoe-and-harness repair shop in Wisner, Connaughton opened a tire business in Wisner in 1926. He sold the first rubber tractor tires to be used in Cuming County in 1934. When tires were scarce during World War II, Connaughton was kept busy rebuilding existing tires. In 1990, Goodyear bought Connaughton's advertising signs to display in the Goodyear Tire Company Museum in Akron. (Both, courtesy of Wisner Heritage Museum.)

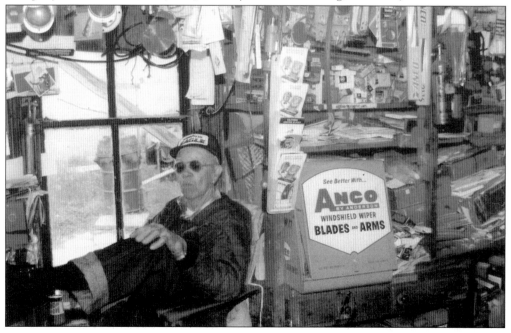

Six

COUNTRY'S MIGHT
BACKING THE CAUSE

It takes a lot to preserve a country's might. Soldiers buried on Cuming County soil took up arms, risking life and limb so that those today might live free. Some came back from the front lines forever changed, physically or emotionally.

Those involved in the military, law enforcement, civil service, and politics have been an active force in Cuming County, along with those who have contributed to the country's might in other ways, like collecting scrap for the war effort, conserving gas rationing cards, going door to door with economic development surveys, or picking up people to vote. People of all ages, political persuasions, and degrees of patriotism have served and continue to serve in Cuming County, even some who are not old enough to join the military, even though they tried..

Take Charlie Schwedhelm, for example. He was in his 80s when he told this story for the first time to his daughter Theresa (Schwedhelm) Reppert.

When Charlie was only 16, he boarded at West Point's Franciscan Sisters of Christian Charity Convent. He found himself with nothing to do one Saturday night.

Theresa told his story as follows: "There used to be about seven, eight trains come through West Point in a day. Now that was a lot of trains then. Everybody went to the depot to see the trains, who came and who left. This one particular Saturday, here comes a train with men hanging out, waving, and yelling and with flags and everything. The Spanish-American War had been started."

Charlie got on the train with the rest. He got halfway to Fremont when the conductor asked for his ticket. Charlie did not have one. When the next train came along, Charlie was handed over to the conductor. They brought him back to West Point, just in time for supper.

"I never before have told anybody," Charlie said, "that I had joined the Army for one day."

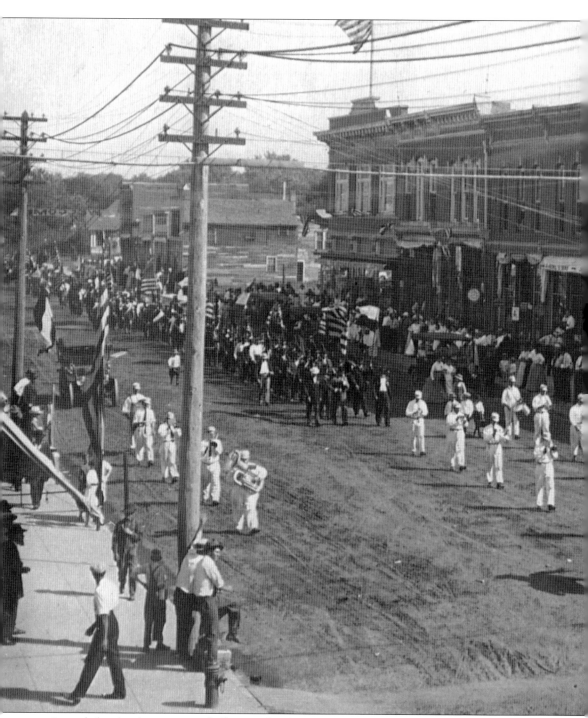

Intended to be the war to end all wars, the Great War was the destination of 56 local soldiers in September 1917, who were given a tearful send-off party in West Point. A rally, program, and dance culminated with a farewell at the West Point depot. After waiting to hear word throughout the fighting, Cuming County residents were relieved when an armistice was signed in November 1918. Upon their return home, World War I soldiers, sailors, and marines followed parade marshals

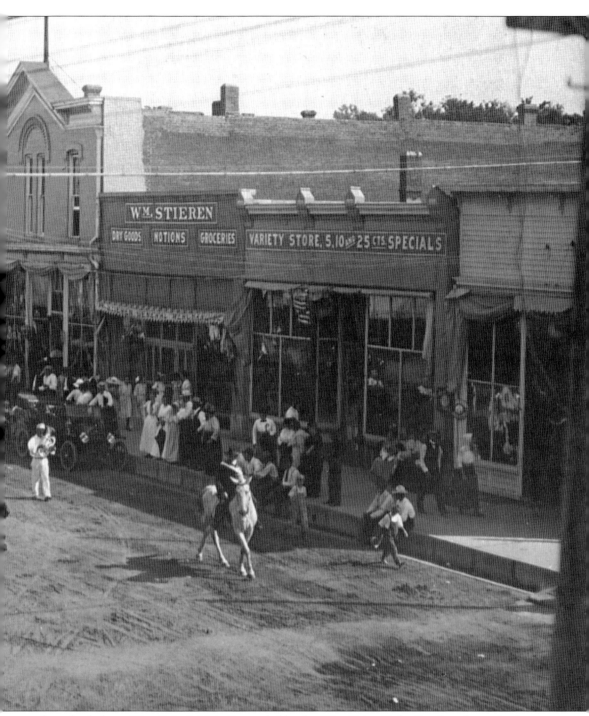

on horseback down West Point's Main Street, led by the West Point Cadet Band, as shown in the photograph. The welcome home celebration, held at Sherman Park, included fireworks, music, dancing, sports of various kinds, and two fine speeches by the Honorable W.L. Dowling of Madison and the Honorable J.C. Cook of Fremont. (Courtesy of John Stahl Library.)

Many Civil War veterans took advantage of the Homestead Act of 1862. A five-year residency and improvements were all it took to earn 160 acres of land. Veterans could deduct the number of years they served from the residency requirement, attracting them to the free land of Cuming County. In 1930, the funeral of Ferdinand Scheibe honored one of West Point's last Civil War veterans. (Courtesy of John Stahl Library.)

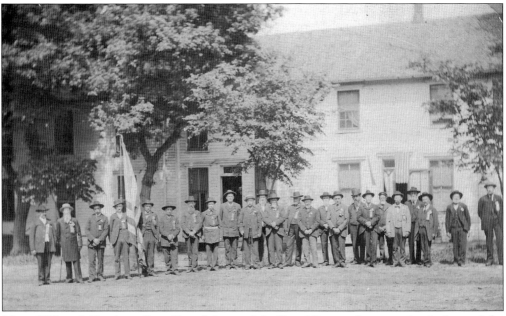

Men of Wisner's Finnicum Post, Grand Army of the Republic, stand at attention in front of the Wisner Hotel in 1907. Holding the sword, second from the left, was post commander Henry Faubel. Farther down the row, the position of flag bearer was a designation of honor. The men are among the 104 who made up the combined membership of Reno Post and, later, Finnicum Post. (Courtesy of Wisner Heritage Museum.)

The Works Progress Administration (WPA) was part of Franklin Roosevelt's New Deal program, set up in response to the devastating effects of the Dirty Thirties and the Great Depression. Designed to provide jobs from 1935 through 1941, the program offered these Wisner women jobs in the WPA sewing center located at the site of the present-day Citizens National Bank. (Courtesy of Wisner Heritage Museum.)

Fletcher L. Farley was a Bancroft soldier killed in action in France in 1918. The Bancroft American Legion, formed in 1920, was named in tribute of Farley, the first Bancroft serviceman to give his life for the cause of freedom. The charter was issued in 1920, with the auxiliary receiving its charter two years later. (Courtesy of Marjorie Vogt.)

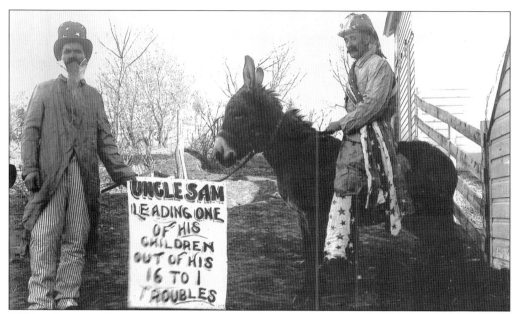

William Jennings Bryan, serving as secretary of state in the cabinet of Pres. Woodrow Wilson, was the Democratic Party's nomination for US president for the 1896 election. As he campaigned in West Point, the West Point Cadet Band, as well as the Wisner Band, played a welcome in his honor. The photograph above shows several unidentified West Point residents anxious to advertise their views while in costume and accompanied by a donkey mascot. Bryan spoke to a crowd gathered by the Cuming County Courthouse, as seen below. Although Bryan received only 47 percent of the county's vote against William McKinley's 51 percent, Bryan carried Nebraska. Eventually, Bryan lost the presidential bid, but a number of Democrats were elected to Cuming County offices for the first time in years. (Both, courtesy of John Stahl Library.)

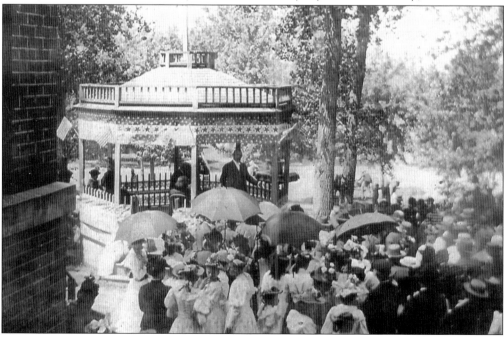

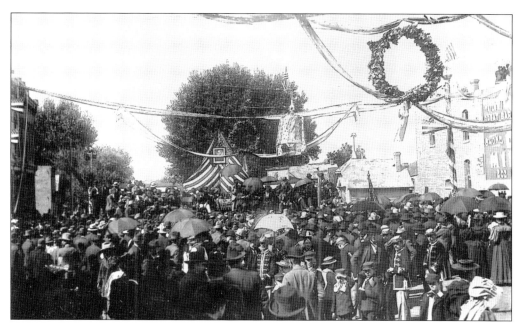

More than 4,000 Cuming County residents welcomed New York governor Theodore Roosevelt to West Point in 1900. Some members of Roosevelt's Rough Riders from the Spanish-American War combined forces with Republican supporters to cheer Roosevelt as he campaigned for vice president on the McKinley-Roosevelt ticket, amid cannon fire, brass band music, and thunderous applause. (Courtesy of John Stahl Library.)

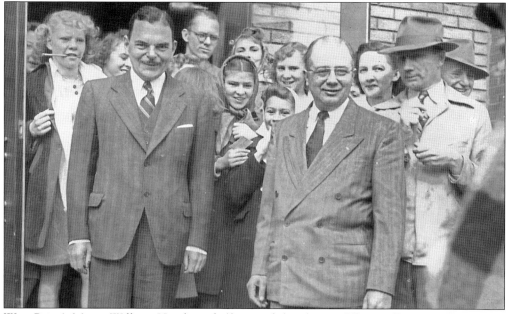

West Point's Mayor William Hasebroock (front right) welcomes Thomas Dewey to West Point in April 1948. Seeking the Republican nomination for US president, Dewey spoke to voters in the city auditorium. His speech proved fruitful as he beat out Harold Stassen in the county vote and won his party's nomination, but eventually lost to Harry Truman in the national election. (Courtesy of John Stahl Library.)

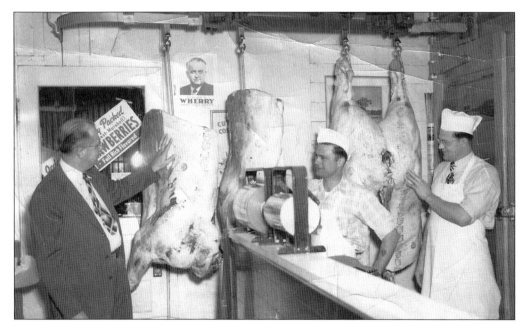

William Hasebroock met with constituents while campaigning throughout Cuming County, including a stop at the meat counter at the West Point IGA Store. A Nebraska legislator from 1961 to 1979, Hasebroock served seven terms as West Point's mayor, plus chairman of Cuming County's Republican Party. On the wall is a poster of Kenneth Wherry, US senator from Nebraska from 1943 to 1951. (Courtesy of Sharlene Clatanoff.)

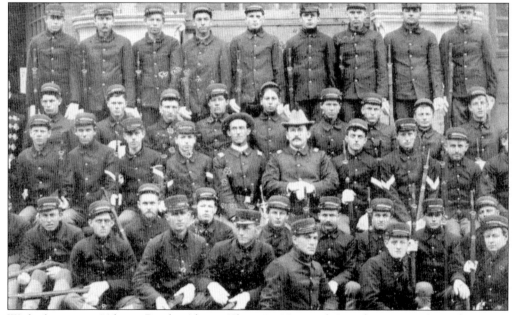

With the motto, "Always Ready, Always There," a National Guard Unit was formed in West Point in 1902. The next year, the Militia Act of 1903 organized various state militias into the present National Guard system. Prepared to respond to domestic emergencies and disasters, West Point's unit held regular meetings and drills, ready to be called up for active duty. (Courtesy of John Stahl Library.)

Seven

ORGANIZATIONS
LONGING FOR COMMUNITY

As Cuming County residents became more settled, they longed for community, establishing churches and schools and enjoying social functions.

Congregations were formed when people of similar beliefs began meeting in their homes or neighborhood schoolhouses. Whether it was their faith drawing them together or the stir craziness of a long, bleak winter, they were drawn in by box socials, school programs, extension club meetings, tractor pulls, tent revivals, and church services.

Bertha Johnson explained it as follows: "Camp meetings were held in the summer and were well attended by the young and old. In the winter, the Methodist Church conducted revival meetings, often lasting six weeks. With music and eloquent speakers, the church would be filled. A 'pound party' for the pastor was always of interest and attended by everyone. In some instances, the articles brought were listed, and the value was applied on the poor preacher's salary. So, his family had rice, prunes and beans, perhaps, instead of dollars."

Lydia (Behling) Lambrecht remembered what it was like when her family attended Lenten services. Her dad harnessed up the horses to a corn wagon with a bench inside to seat the family, bundled under blankets, as he drove the team and wagon through the farm pasture to the main road. "We didn't have too many excuses for not attending church," Lydia said.

When it came to excuses, Arvolene Martin found there weren't many she could make to get out of attending church either.

"I can hardly ever remember missing a Sunday going to church," she said. "You would have to be on your death bed, the snow so high or the mud so deep that you couldn't get through, to miss church."

Faithfulness, dependability, steadfastness, and so on, Cuming County residents kept the church pews warmed, schoolhouses filled, and social functions hopping.

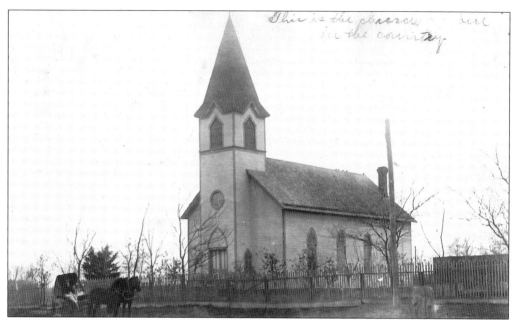

Immanuel Lutheran Church, located in rural Beemer, has the distinction of being Nebraska's oldest Missouri Synod Lutheran congregation. In 1868, when 19 families petitioned for a pastor near the settlement of Rock Creek, the church was known only as the Lutheran Church. The first church was built in 1871 on the Elkhorn River bluffs. A larger church, pictured here, was built one-mile south in 1887. (Courtesy of Vernon Schultz.)

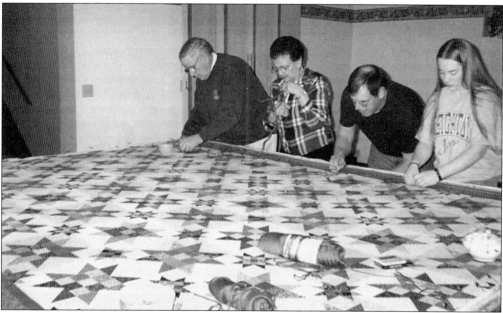

As those of the Mennonite faith settled near Beemer, they secured a rural schoolhouse as a meeting place in 1895. Worship services were spoken in German. With a growing membership, they erected the Plum Creek Mennonite Church building in 1907 north of Beemer and, in 1959, relocated into town. Members of the Beemer Mennonite Church, as it is now called, tie quilts as one of their projects. (Courtesy of Beemer Mennonite Church.)

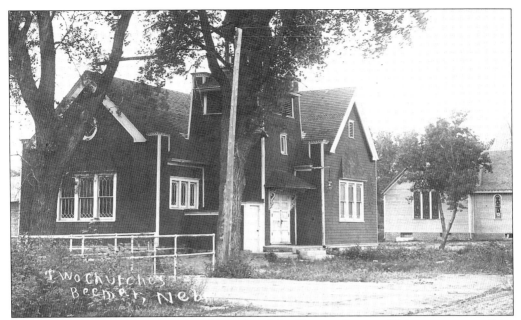

First Congregational Church is the oldest church building in Beemer. Thirteen women of the congregation hauled the first two loads of brick for its construction, with two women supplying teams and wagons. Nine months after its organizational meeting, dedication took place in 1890. In the background is the Methodist Episcopal Church, dedicated in 1886 and located on the east end of the same block. (Courtesy of Fred and Terri Schneider.)

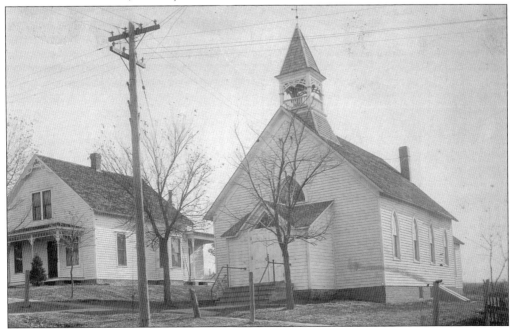

Christ Lutheran Church of Wisner, pictured here, was organized in 1897, with a church and parsonage built the same year. Around the same time, St. Paul's Lutheran Church was organized north of Wisner, with a church built in 1895. As early as 1906, pastors served the two congregations jointly, and in 1948, the two congregations voted to merge. (Courtesy of Wisner Heritage Museum.)

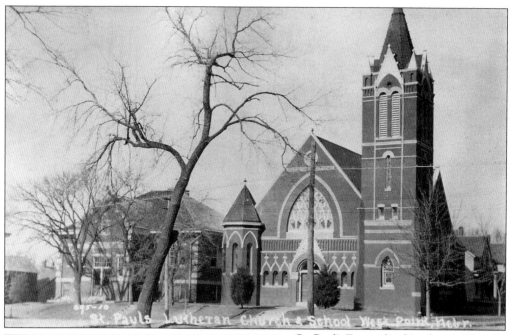

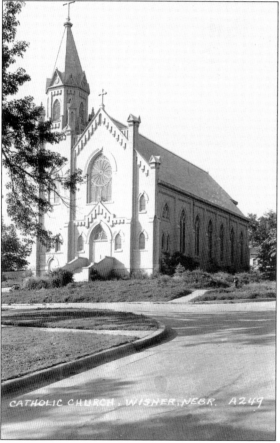

St. Paul's Evangelical Lutheran Church formed in West Point in 1871, with a building erected in 1873. Before that time, members met in homes until they could put together the $1,400 it would take to build a church. In 1892, the cost of erecting a second church, shown here with the school, was estimated at $9,000. (Courtesy of Laura Franchini.)

St. Joseph Catholic Church was founded in Wisner in 1879 as a mission project of St. Mary's Parish in West Point. In 1893, a frame church was built. A new brick church was erected in 1920 under the direction of Fr. Joseph Rose, a master in architecture. Local farmers with horses and wagons dug the basement, and many congregational members volunteered their assistance. (Courtesy of Jim Bahm.)

The Evangelical United Brethren Church of West Point was formed in 1869. A brick building was erected in 1871 with two separate entrances: one for men and one for women. In addition, a partition kept the two sexes separated throughout the service, a common custom of the day for that denomination. (Courtesy of John Stahl Library.)

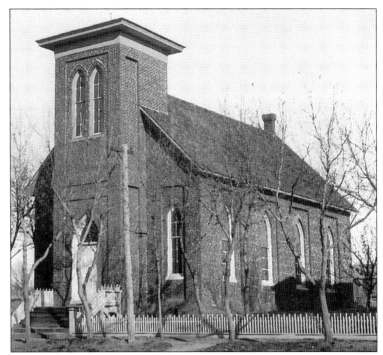

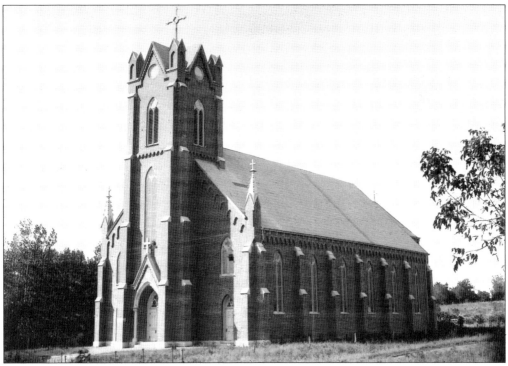

St. Mary's Roman Catholic Church formed in the fall of 1874, with the first Catholic settlers meeting in St. Charles Township as early as 1859. Services were held in private homes while Iowa missionaries tended to parishioners' needs. In 1875, the first Catholic church in West Point was built. Pictured here, a second church was built in 1881. (Courtesy of John Stahl Library.)

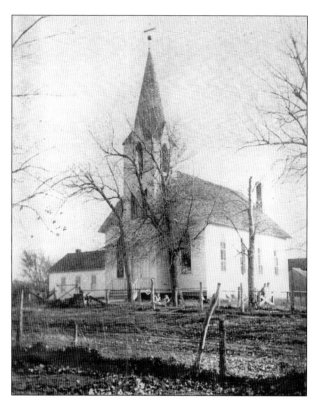

St. John Evangelical Lutheran Church, with its school in the photograph to the left, organized in 1876 when a group of German settlers from Cuming and Stanton Counties met at a country schoolhouse. Eventually, they built a church south of Wisner. The congregation combined with nearby Zion Lutheran congregation in 1959. Members of St. John's congregation assisted in forming a second St. John's in Beemer, pictured below, organized in 1893. German writing above the door of the church's original building states, "German Evangelical Lutheran St. John's Church, 1893." (Left, courtesy of Vernon Schultz; below, courtesy of Fred and Terri Schneider.)

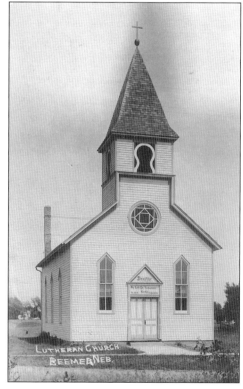

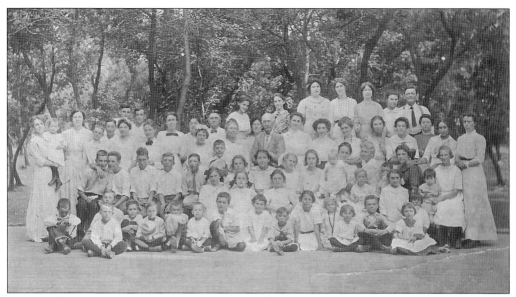

Dedicated in 1880, the building once housing the Congregational Church still stands at the corner of Park and Lincoln Streets in West Point. In 1915, Sunday school members and teachers of the Congregational Church gathered for a picnic and posed for this photograph. (Courtesy of John Stahl Library.)

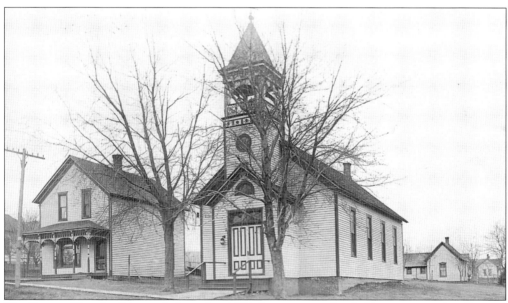

The Baptist Church of Bancroft formed in 1877. Services were first held at country schoolhouses, with a rural church built in 1881. In 1892, approximately 27 souls were counted, but by 1908, the church had closed, and the church and parsonage (left) were sold, including the church's red, wooden weather vane, which was shaped like a codfish. (Courtesy of Henry Heller.)

Just before graduation, high schools marked the end of the school year with a banquet and prom, inviting faculty, juniors, seniors, and their dates. The junior class typically hosted the event. Marion Dewitz captured images of the Wisner High School prom in 1923, with some of the juniors pictured here. (Courtesy of Wisner Heritage Museum.)

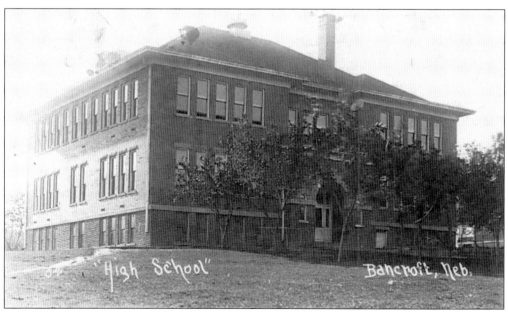

Bancroft's District No. 20 underwent a number of changes since its 1870 formation. The first schoolhouse was moved into Bancroft in 1884 under a moonlit sky from its location two miles out in the country. By 1904, the structure was inadequate, and a brick building was constructed in 1905 at the same location. (Courtesy of Marjorie Vogt.)

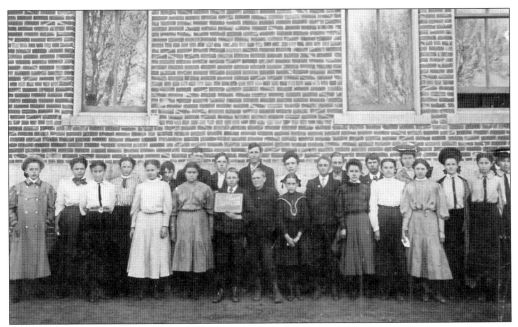

Rural school eighth-grade students were required to take the eighth-grade exam at the end of their final term. Students had to prove proficiency in grammar, arithmetic, US history, geography, and orthography (the study of spelling). In this 1907 photograph, Cuming County rural students line up in West Point with one of them showing a sample certificate. (Courtesy of John Stahl Library.)

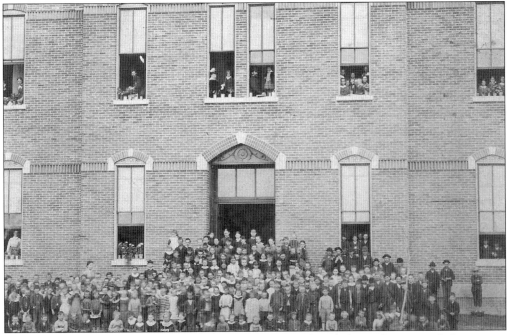

In 1881, West Point High School stood two stories high with eight large classrooms. In later years, the third-floor attic was utilized, and an addition on the east side of the building was constructed. Even so, with students peeking out of second-floor windows and the overflow below, this photograph shows the school's crowded conditions by the 1920s. (Courtesy of John Stahl Library.)

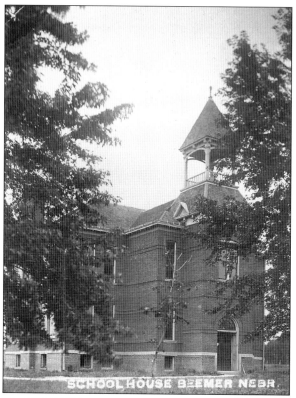

The first Beemer Public School session was held during the winter of 1885–1886 in a small building. In 1886, a wooden, two-room schoolhouse followed. By 1891, this schoolhouse became crowded, and a modern brick building was erected for the 210 students enrolled. Twelfth-grade students attended West Point. This building was used until 1918. (Courtesy of Fred and Terri Schneider.)

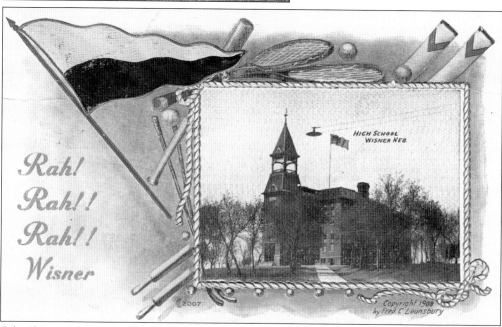

School District No. 30 was organized in January 1872 with a frame schoolhouse built the same year. By 1883, a brick building was constructed, divided into four departments, with the site comprising an entire city block. Wisner High School consolidated with Pilger High School in 1969, and a new building went up on the west edge of Wisner. (Courtesy of Jim Bahm.)

Guardian Angels School in West Point opened in 1885. The school was replaced with a three-story, brick building next door in 1918, graduating its first high school class in 1921. In the early 1950s, the top floor of the school and auditorium were remodeled and used for classrooms, while the first school building served as a convent and boarding school for rural students. Guardian Angels students participated in a grade school play in 1918, shown in the photograph above. In 1927, the upper floor of the second building was decorated in observation of the golden jubilee of the ordination of Msgr. Joseph Ruesing, pastor of St. Mary's Catholic Church. (Both, courtesy of John Stahl Library.)

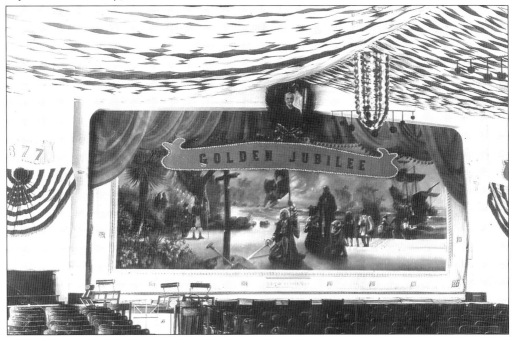

District No. 34 patrons, located southwest of Wisner, first met in 1872 in a dugout and in a log house a year later. The first school term took place in 1873 in a frame house. A school building went up in 1874, with a second building constructed in 1890. Sunday school was held there in the early 1900s for those of various nationalities and faiths, with a new school erected in 1912. One of the oldest country schools in Nebraska, the school closed in 1967. Some of the students were of the fifth and sixth generations of the district's pioneer residents. Students are seen enjoying ice cream in the photograph above, and the school property is lined up for sale in the image below. (Both, courtesy of Marlene Hansen.)

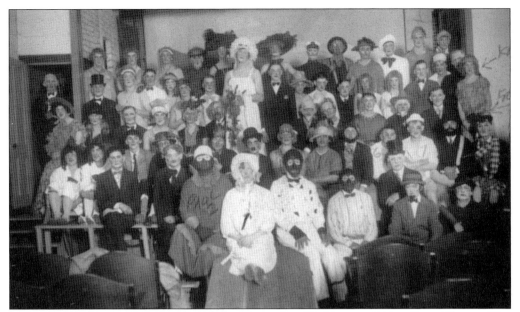

The Bancroft Women's Club organized the Womanless Wedding in 1928 at Draw Theater. The identity of the bride, appearing in a fluffy veil to hide his face, was kept secret until the final moment. Profits from the evening's entertainment were used to build a bandstand for summer concerts. (Courtesy of Marjorie Vogt.)

This delightful photograph, with the words "Rooster Drill" on the back, belonged to Marguerite Nellor who attended Beemer School. Reece Studio of Wisner took it, possibly in the 1920s. Perhaps, the youngsters were taking part in a school play or pep rally. (Courtesy of Sharlene Clatanoff.)

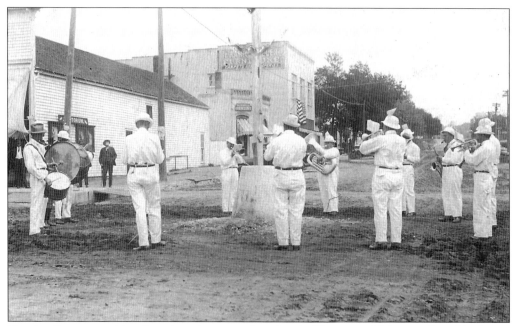

Cuming County musicians have been known to form bands. The county's Missouri Synod Lutheran Churches provided musical entertainment at summer outdoor mission festivals, and West Point's Sunshine Center formed the Sunshine Band and the Kitchen Band, complete with washboards. The West Point City Band is a prime example of a community band, performing in the round in 1920 on a city street, as pictured above. A couple married in 1884 waits for the music to begin on their golden wedding anniversary in the dance hall above the Otto Schwinck Garage in West Point. (Both, courtesy of John Stahl Library.)

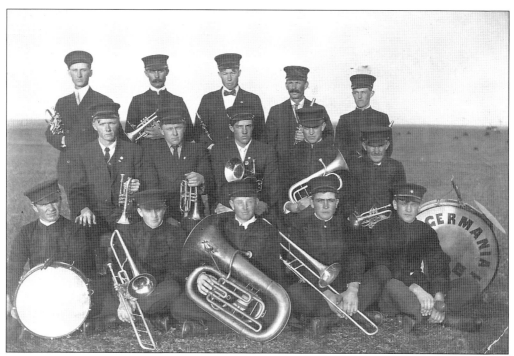

Those who could beat time on a drum or toot out a tune on a trumpet, trombone, baritone, or French horn were in demand when neighborhoods formed bands. Photographed in 1912, the band in the photograph above was made up of musicians from Bismark and Elkhorn Townships southwest of Beemer. In the image below, young men from the West Point area started up an old-time band at county fair time, believed to be in the 1890s. (Above, courtesy of Vernon Schultz; below, courtesy of John Stahl Library.)

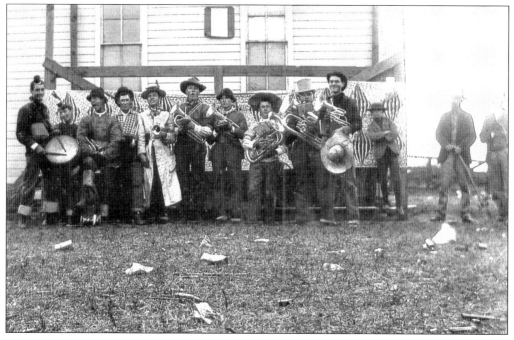

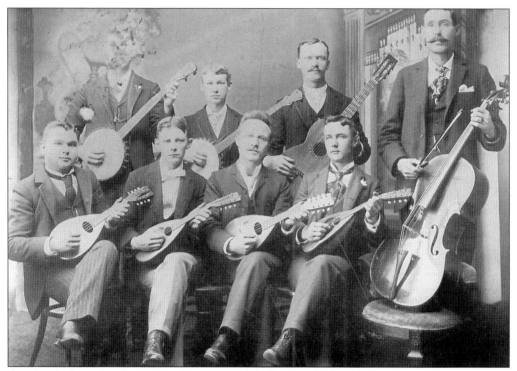

Amidst the brass bands, singing societies, and drill teams finding a voice in West Point society, one of the most unusual was the West Point Mandolin Club. Organized in the early 1900s, club members entertained often at various events. (Courtesy of John Stahl Library.)

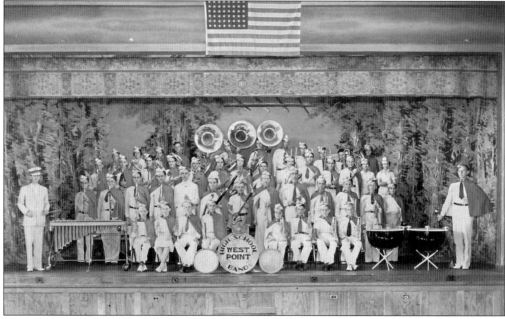

Many high schoolers joined the marching band, with this 1936 West Point High School band as a prime example. In later years, outstanding members from the county's high school bands were singled out with a John Philip Sousa Award. (Courtesy of John Stahl Library.)

Physical culture programs were designed to combat diseases of affluence. They incorporated folk games, dances, and sports, along with military training and calisthenics. Indian clubs, medicine balls, and dumbbells were utilized in the programs, along with fencing, boxing, and wrestling. West Point's Women's Physical Culture Club met in the late 1890s. (Courtesy of John Stahl Library.)

Elaine (Stark) Raabe went to bat at the end-of-the-year picnic at Zion St. John Lutheran School, south of Wisner, in May 1968. Many parents joined in on the fun as adults and children alike chose teams. Elaine and Vern Raabes' five children all attended classes at St. John or Zion St. John School. (Courtesy of Vernon Schultz.)

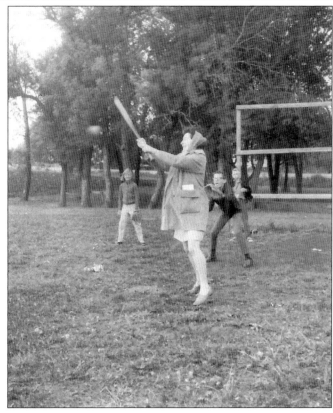

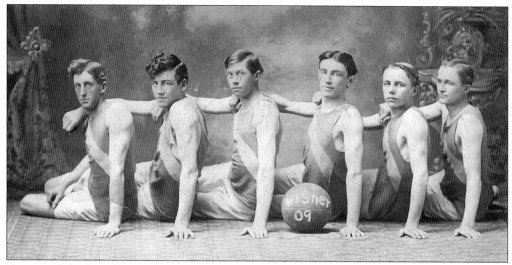

Two peach baskets fastened to a gymnasium balcony in Springfield, Massachusetts, in 1891 prompted the humble beginnings of basketball. The only major sport originating solely in the United States, basketball became a popular sport in Wisner in 1909, with the community making up a team to compete against neighboring town teams. (Courtesy of Laura Franchini.)

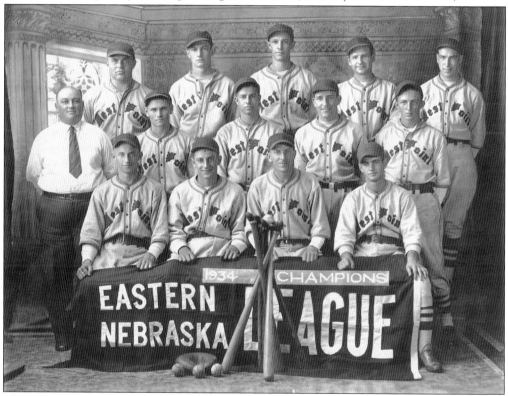

This West Point baseball team took home the coveted Eastern Nebraska League trophy two years running: 1933 and 1934. Baseball rose in popularity in the years between World War I and the Great Depression, due in part to the glory days of Babe Ruth, one of the greatest hitters in the history of baseball. (Courtesy of John Stahl Library.)

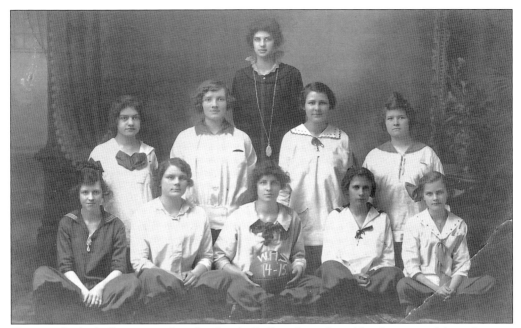

Women's basketball originated at the Smith College for girls in Northampton, Massachusetts, in 1892. Wisner High School girls came to enjoy the sport as well, as shown in this 1914–1915 photograph of the team and their coach. (Courtesy of Laura Franchini.)

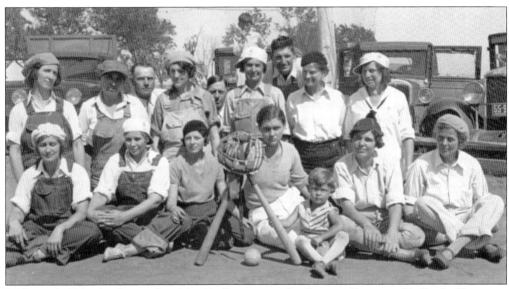

In the mid-1930s, this Bancroft girls' softball team won the Cuming County softball title. Playing in jeans and overalls did not hamper the girls' style one bit as they slammed balls to the outfield and slid into home base. Perhaps, the batgirl was their good luck charm. (Courtesy of Marjorie Vogt.)

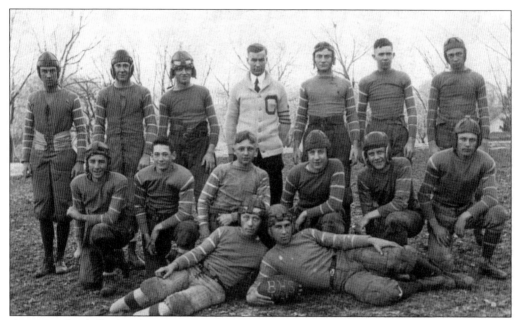

American football, played on Cuming County's chalk-marked fields, had its roots in mob football played in Britain. The games were mainly unorganized until football came to college campuses in the early 1800s. Rules were simple at that time, and violence and injury were common events. Coaches made changes to the game, and the rules were published in 1871 to standardize the game. Bancroft's town team is lined up in the above photograph, and below, West Point's players of the 1903 high school team are seen in padded pants and laced-up jerseys. (Above, courtesy of Marjorie Vogt; below, courtesy of John Stahl Library.)

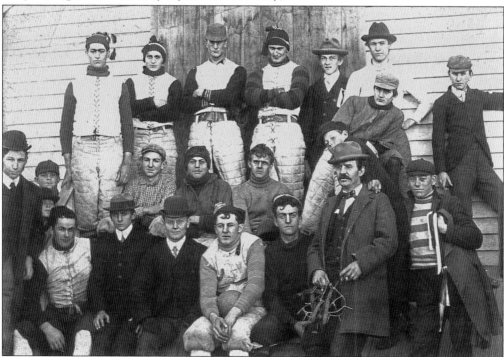

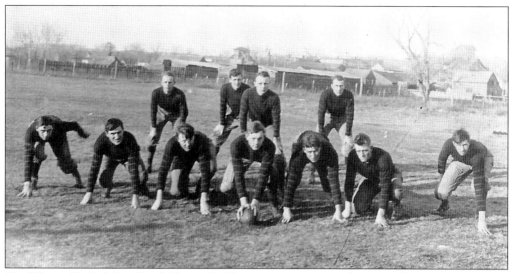

The Wisner High School football team held rigorous practices to defeat rival teams. This Wisner high school team is said to have practiced drills and plays near the site of the present Wisner sale barn, photographed above. The town team in the image below is rumored to have gone down in history as beating the Bugeaters, representing the University of Nebraska, in the 1892 college football season. In addition to being known as the Bugeaters in the early years, the University of Nebraska, Lincoln, team was also called, on occasion, the Old Gold Knights, Tree Planters, Nebraskans, the Rattlesnake Boys, Red Stockings, Antelopes, and Goldenrods. (Both, courtesy of Laura Franchini.)

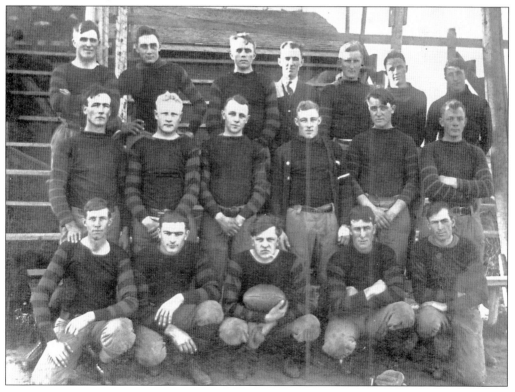

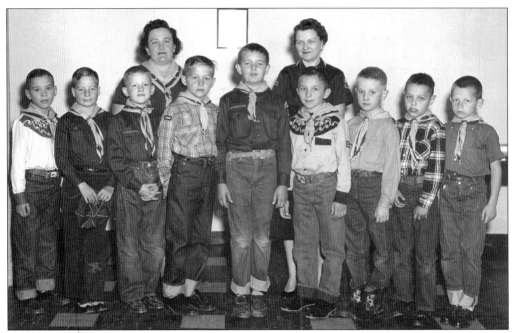

The first Boy Scout troop in Wisner was organized in 1923. As with other groups designed for youth throughout Cuming County—Cub Scouts, Girls Scouts, Brownies, Campfire Girls, and 4-H Clubs to name a few—leaders dedicated their time and talents. Den mother Betty Myers (back right) led this 1957 troop; Loretta Tietz (back left) assisted her. (Courtesy of Wisner Heritage Museum.)

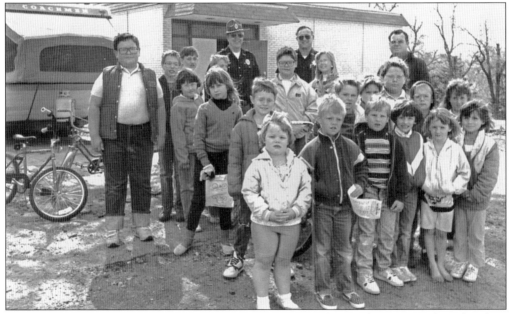

Many of Bancroft's youth completed educational programs designed to improve bicycle-riding behavior. In the early 1990s, area youngsters attended bicycle safety courses at Bancroft's Catholic Center. Classes were taught by Nebraska State Patrol trooper Ken Bures (back left) and Bancroft Police chief Bob Greiner (back center.) (Courtesy of Marjorie Vogt.)

Eight

TRAGEDIES
PERSEVERANCE DURING GREAT LOSS

William Glaubius settled in Cuming County in the 1800s. For three years, his only vehicle was a sled made by splitting a log, so he walked six or seven miles to work at the neighbors' farm each morning. He then worked all night to take care of his own crops, which, despite his efforts, were destroyed by grasshoppers. In 1876, all his buildings and property were destroyed by prairie fire.

Some years, if the grasshoppers did not get the crops, prairie fire, drought, wind, or hail did. As the old song goes, if it were not for bad luck, in some years, Cuming County farmers had no luck at all. For example, in 1874, the thermometer read 90 to 106 degrees for three weeks straight, accompanied by a strong south wind, burning the wheat. The grasshoppers got the remaining scorched stalks; the air was so filled with them that it looked like a snowstorm was underway. This lasted from 10:00 a.m. until nightfall.

Merle Martin remembers the Beemer area was doubly hit during the years of the Great Depression because, as he said, "The Wupper bank went broke in 1929, and it took a lot of people's money with it. If we saw a dime every two weeks, that was about it."

Joyce Toelle's parents' farm, situated south of Beemer, was so dry, the only tree they were able to keep alive during the dry years was one evergreen tree. They often had little drinking water for themselves or the livestock. "Sometimes, we would not have enough water to even take a good bath," she said.

Even so, despite train wrecks and car crashes, crop failures and bank collapse, fire, flood and bankruptcy, Cuming County people have persevered.

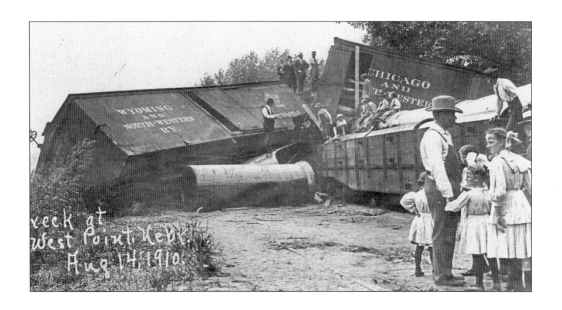

The groaning shriek of crashing metal woke the countryside around West Point as this massive train careened off the track and piled up with one car against another on an August day in 1910. Heavy rains washed out supporting rail lines and derailed both engines on train No. 39 of the Chicago & North Western Railway, seen above. Men lined up along the tracks with shovels and pick axes in hand for several days to assist the railroad crew in repairing the damage. Speedy restoration was vital to the ongoing development of industry and agriculture in Cuming County, as well as for travel at the end of the 19th century. (Both, courtesy of John Stahl Library.)

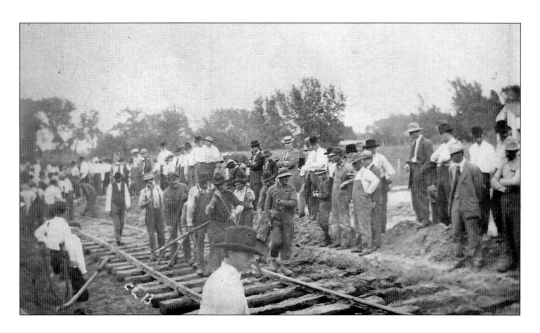

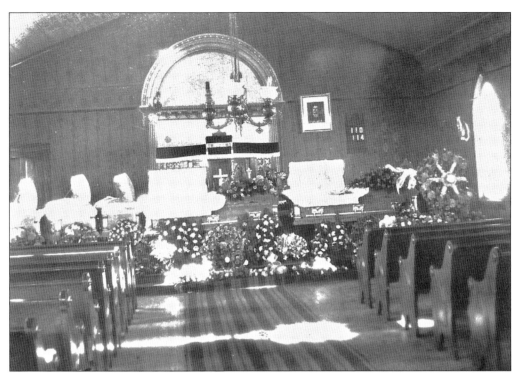

Five members of the Von Seggern family were killed on Christmas Day 1925 when their Buick sedan collided with a train at an intersection between Pilger and Wisner. The lone survivor was Fred Jr., as the accident killed his parents, two sisters, and brother. Five caskets were lined up at the front of St. Paul's Evangelical Lutheran Church, located north of Wisner, for the funeral. (Courtesy of Marianne Von Seggern.)

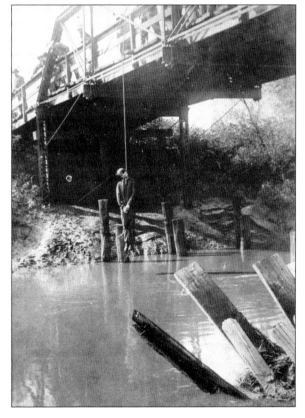

A man believed to have murdered a Rosalie couple was lynched in 1907. Lorin Ray Higgins was a hired hand of the Copples, escaping from the farm before the couple was found shot and beaten to death. Later, Higgins was arrested near Hooper. Headed for trial, Higgins was taken from the train at the Bancroft depot and hanged by a vigilante group. (Courtesy of Marjorie Vogt.)

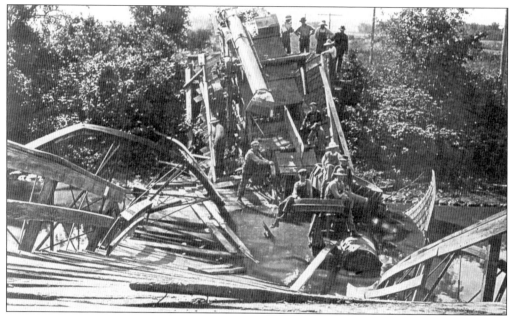

The weight of a steam engine was too much for this river bridge arching over Plum Creek near West Point. Moving the heavy machine around from farm to farm to thresh grain could be problematic, especially when traveling over wooden bridges along country roads. Around 1910, horse-pulled combines appeared, and scenes such as this disappeared. (Courtesy of John Stahl Library.)

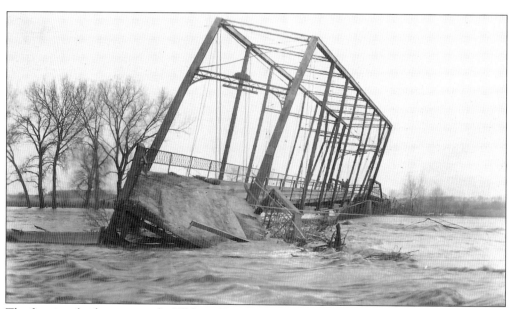

The first iron bridge to span the Elkhorn River at Wisner was built in 1873. In 1888, heavy rains washed it out, and a ferryboat was used to cross the river. In 1921, flooding caused *Old Narrow Sides* to lurch from its moorings, as shown. A temporary wooden extension spanned the Elkhorn while the bridge was built at another location. (Courtesy of Marge Holland.)

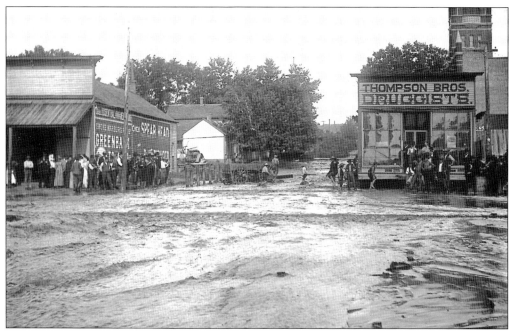

On June 25, 1891, after four weeks of heavy rains, a cloudburst deluged West Point. Wind, rain, and lightning combined in a storm of such great intensity, water rose several feet deep on Main Street. In the third ward, rescuers swam through the floodwaters to help residents into safe shelter in the school, city hall, or other homes. (Courtesy of John Stahl Library.)

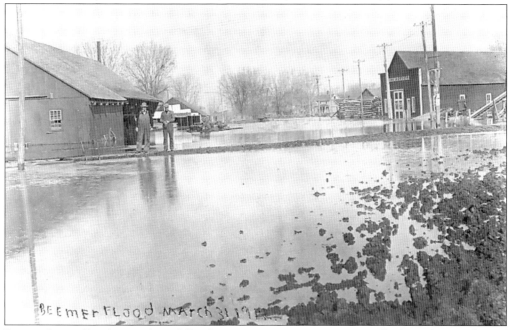

Beemer has suffered a number of floods since its incorporation, typically from the overflow of Frazier Creek, with overflows known to wash buildings right through town. Floodwaters of the Elkhorn River also deluged the town, even though the river is located a mile away. In March 1912, the Elkhorn River was the culprit, resulting in this view. (Courtesy of Henry Heller.)

Seventy-mile-an-hour winds combined with sleet and snow began Cuming County's winter storms of 1948–1949. Prompted by thunder and lightning, November's first snowfall blanketed the region. Homes were left without heat, light, and water; downed telephone lines left them without communication as well. The Army Corps of Engineers dug through blocked roads, some of them impassable from November through a muddy June. Drivers—and even this dog perched on top of the car on a Wisner road—had to wait until roads were cleared to get from place to place. Once youngsters were able to reach school, they relished winter games of fox and geese and king on the mountain, as did these students at St. John's Lutheran School south of Wisner. (Above, courtesy of Laura Franchini; below, courtesy of Norm Kersten.)

In addition to answering fire calls within city limits, Cuming County fire departments are also called to put out fires in the country. Whether the alarm sounds for a field set ablaze by a spark from a piece of farm machinery or a carelessly thrown cigarette or for smoking buildings, such was the case for this barn near Bancroft, volunteer firefighters answer the call. (Courtesy of Marjorie Vogt.)

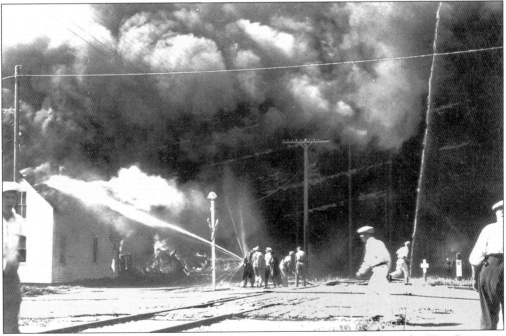

It was a hot and windy July 4, 1936, as the wind carried fireworks sparks from the West Point city park to the roof of a nearby livery barn. As temperatures reached 108 degrees, Beemer and Wisner assisted West Point firefighters. The barn, homes, and businesses were damaged or destroyed. As a result, the mayor banned future fireworks. (Courtesy of John Stahl Library.)

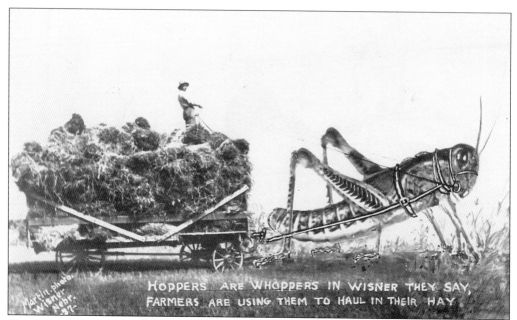

HOPPERS ARE WHOPPERS IN WISNER THEY SAY,
FARMERS ARE USING THEM TO HAUL IN THEIR HAY.

Grasshopper plagues played a serious role in the settlement of Cuming County, leaving early settlers without food or a crop. In the 1930s, the hoppers were whoppers in Wisner, and according to this 1937 postcard from Martin Photography in Wisner, they were so big from dining on surrounding fields that the farmers were using them to haul in their hay. (Courtesy of Vernon Schultz.)

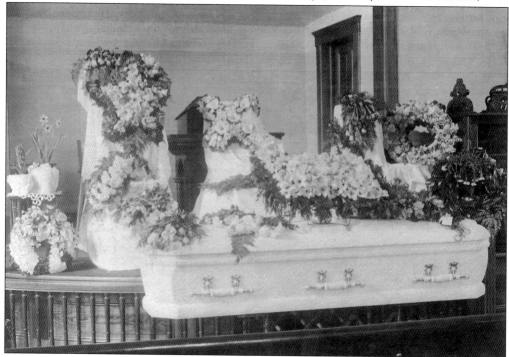

Believed to be photographed at the United Methodist Church in Beemer, the casket and floral arrangements may have served as advertising for Joseph A. Shors's funeral parlor. The light-colored casket was likely reserved for burials of females. (Courtesy of Sharlene Clatanoff.)

Nine

ENTERTAINMENT
HOMEMADE FUN

Sometimes a person had to make his or her own fun. Sisters Julie and Lois Behling, born in the 1920s, made theirs in the family's grove. They pulled binder twine from bales of hay and tied the pieces together. They then roped off rooms as they tied twine from one tree to the next. They used pieces of wood for chairs and an old stove or something similar to put in their kitchen.

"We would play for hours out there in the summer," Julie said. Oftentimes, homemade fun centered on music.

When Regina Meyer was young, she pretended the windowsill was her piano until her dad bought her a used organ. Her first lessons were sent to her through the mail. She practiced the music, was tested on it, returned the test to the company, and the company sent her a new lesson. She ran through scales and practiced long enough that she eventually played for church. She played hymn after hymn on the old pump organ, pedaling the bellows for hours.

Even after ball games, fun centered on music. "We always played baseball every Sunday afternoon, and there was different teams," Regina Meyer remembered. "Two teams [were] Rock Creek and Maple Creek. Then when it was over with, they'd huddle up, and they'd say 'Where we going to the dance tonight? Clarkson or Howells or Dodge?' Then we'd all be there again."

They were careful about going to dances, however. "I can always remember," Regina said, "the pastor said if you go to the dance, you cannot go to communion on Sunday."

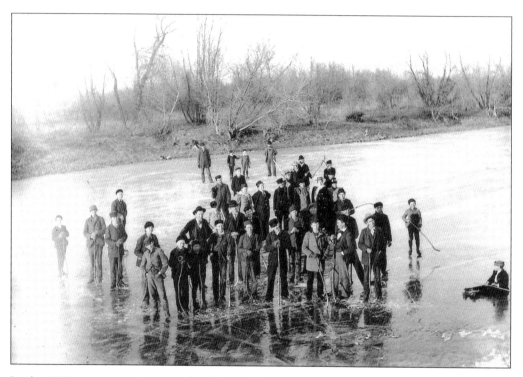

In the 1890s, once weather turned cold enough and the ice on the river or a nearby creek was thick enough, people of all ages slipped on their ice skates, grabbed their hockey pucks and sticks, and took to the ice, as seen above. Ice hockey games and ice-skating parties gave Cuming County residents something to entertain themselves with on cold winter days. In the summer, young people met to swim. As the 1918 photograph below shows, fallen trees along the riverbank provided a place to rest after a vigorous swim and also served as a diving board of sorts. Both images were captured at the Elkhorn River near West Point. (Both, courtesy of John Stahl Library.)

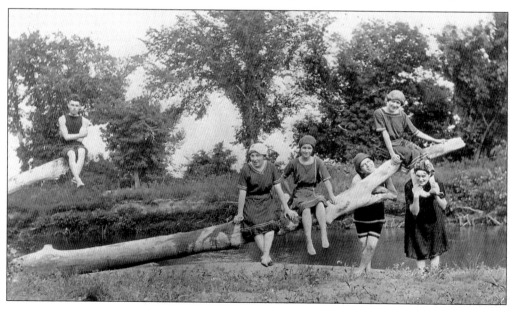

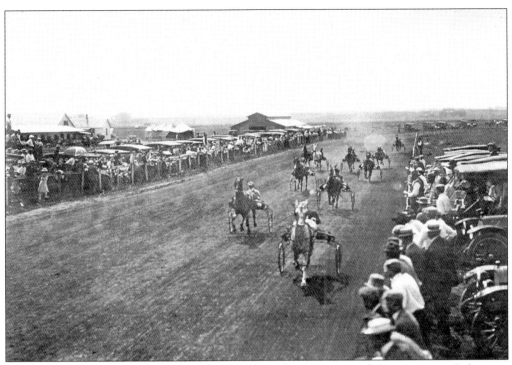

People lined the racetracks of Coney Island in the early 1900s to watch harness races. Delivering trainloads of people from other towns, local livery barns provided taxi service to the racetrack west of West Point. In addition, a grandstand and concessions stands for fans, a dance pavilion, and swimming pool with a water slide attracted visitors to the popular amusement park. In the postcard below, a fictional "Psota's Yacht" ferries visitors under the Elkhorn River Bridge to Coney Island Park. Owner and operator of Coney Island was Anton Psota, known as "the corn king of the Elkhorn Valley" because of the tall corn he grew on his farm. (Above, courtesy of John Stahl Library; below, courtesy of Sharlene Clatanoff.)

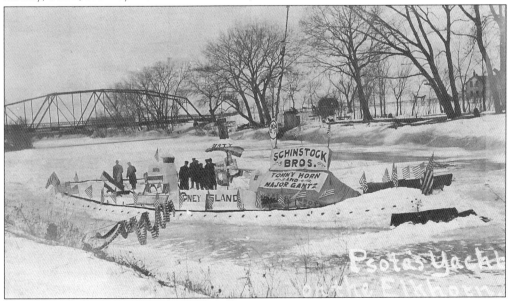

Pictured above, Francis Lorensen (left) taught his horse Doc how to jump over a bar on the family's farm near Wisner. Farm families made their own fun, sometimes resulting in exciting careers. Jimmy Murphy of Wisner and his sister Rita practiced Hippodrome stands, Russian drags, and one-foot shoulder stands on speeding horses in an arena northeast of Wisner to an appreciative, local crowd in the 1940s. Eventually, Jimmy went on the rodeo circuit from 1949 to 1965, working with such big names as Roy Rogers, Dale Evans, Arthur Godfrey, Michael Landon, and Dale Robertson. He was named World Champion Roman Rider in 1956, standing on the backs of matching white horses as they jumped through a flaming hoop. (Above, courtesy of Laura Franchini; below, courtesy of the late Jimmy Murphy.)

Ole Paulsen of Wisner purchased the five-gaited American saddle horse, Denny, in the 1940s. A chestnut horse with a lengthy pedigree, Denny stood 26-to-27 hands high. A five-gaited horse is typically a bold, powerful horse since its gait calls for it to have only one foot on the ground at a time. Denny was pictured on publicity stills for the 1959 television show *You Asked for It*. Willie Teebken, who ran a blacksmith shop in Wisner, constructed a fire-bearing hula hoop in 1958. When his daughter's fire baton and hula hoop act was featured on the show, Denny appeared on the advertisements for it, as seen above. Paulsen and Denny led numerous parades in Wisner, with the horse prancing in time to parade music, pictured below. (Both, courtesy of Jack Record.)

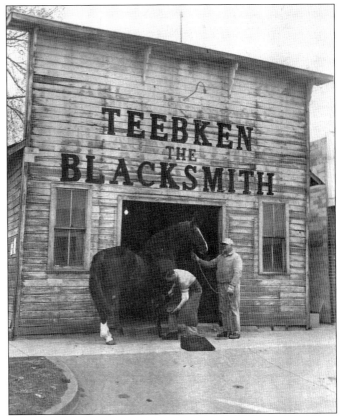

Tommy Horn was a popular harness racehorse owned by brothers Henry and Chris Schinstock, both of West Point. Tommy Horn, shown here with his trainer, was named the 1914 champion harness racing horse. The horse ran on to win seven world records. (Courtesy of John Stahl Library.)

West Point's first recorded circus arrived in 1878, erecting tents on the grounds near the depot. In 1890, the Ringling Bros. Circus paraded through West Point's Main Street. The progress of the five Ringling brothers' circus was slow until 1888, when they bought their first elephant. (Courtesy of John Stahl Library.)

The Rock Creek baseball team began loading bases in 1894 on a diamond at St. John's Lutheran Church in rural Beemer. At the time Rock Creek team entered this float in the Wisner Livestock Show, young men of the Moeller and Raabe families made it up in large part. As the 1970 Northeast Nebraska champions, the team's float's sign read, "No other team can make this statement." (Courtesy of Vernon Schultz.)

The Huddle Bar was the backdrop for its own float in this Wisner parade. The building boasted a butcher shop in 1893, followed by a grocery store with a dressmaking shop above, and later, a law office. In 1959, the building became the Huddle, a favorite place for townspeople to gather for conversation, cards, and brew. (Courtesy of Vernon Schultz.)

West Point Flour Company designed this float for a local parade. Bags of flour were purchased for the product inside and also for the cloth sacks in which the flour was packaged. Housewives bartered with neighbors or had the store save enough sacks of a certain print to have enough fabric to sew a dress, towels for the kitchen, or even underwear. (Courtesy of John Stahl Library.)

Bancroft's annual fall festival included this kiddie parade, marching through the town's main street. The youthful members of the community walked or rode bicycles and tricycles while sporting colorful banners or helium-filled balloons. (Courtesy of Marjorie Vogt.)

In June 1949, Bancroft celebrated its 65th birthday. Women wore sunbonnets and prairie dresses, and men joined the Whisker Club for the two-day event. An elaborate pageant titled, "Then and Now," kicked off the celebration. A birthday cake float appeared in the event's parade, photographed above. In the image below, an antique fire truck pulled a hose cart through the parade, followed by other colorful entries. Profits from the celebration went to complete the American Legion's Memorial Building. (Both, courtesy of Marjorie Vogt.)

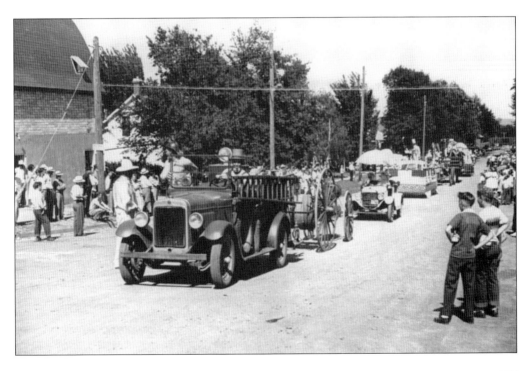

People lined up along West Point's Main Street at the 80th anniversary of the town's founding. Following the theme, "Remembering the Pioneer Days of 1860," the 1940s parade included 10 inflated balloons once flown in a Macy's Day parade. A judge, ring, basket of groceries, and marriage license awaited any couples volunteering to be wed on Main Street that day. (Courtesy of John Stahl Library.)

Hometown movie theaters in the 1920s and 1930s were nicknamed "picture palaces" because of their plush interiors. Uniformed ushers led moviegoers to their seats as a piano or organ provided music. When the stock market crashed in 1929 and banks and businesses failed, people had little spare change to buy a ticket. West Point's Rivola Theater is pictured in the early 1930s. (Courtesy of John Stahl Library.)

Card games often kept people entertained during the early 1900s, as this studio portrait shows, whether playing German *schafkopf*, Czech *tarok*, euchre, pinochle, rummy, or poker. Photographed with a lively game of cards on the table, along with glasses of ale, these five West Point locals decided to record their favorite pastimes for posterity. (Courtesy of John Stahl Library.)

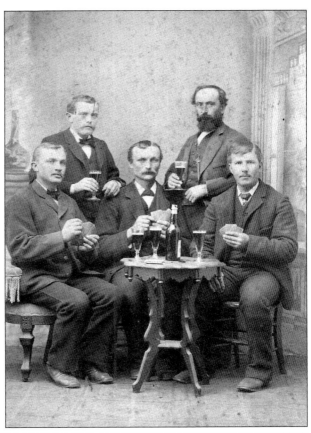

Open-air pavilions and upstairs dance halls drew in dancers, whether the music sang the steps of a polka, waltz, or schottische. Typically, the occasion called for at least one musician with an accordion to squeeze out a tune or a full dance band, such as Professor Faltys' Superb Orchestra from 1916. (Courtesy of John Stahl Library.)

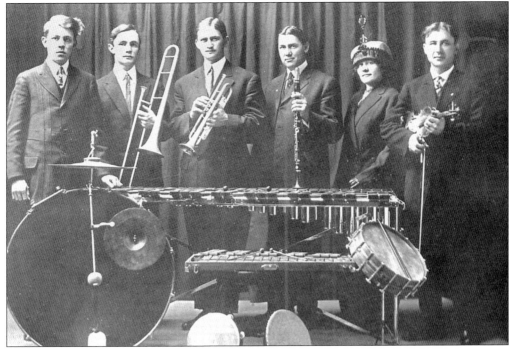

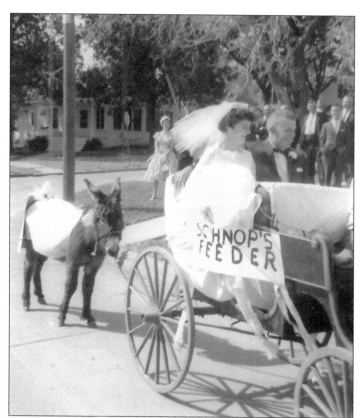

Dale Pestel and Marion Sullivan of Wisner were given a lift in a spring buggy by a team of Shetland ponies following their 1961 wedding. In a neighborhood prank reminiscent of shivarees and other housewarming tricks, friends of the couple tied to the wagon a donkey named Jacob, given to them as a wedding gift. (Courtesy of Vernon Schultz.)

Anniversaries, birthdays, and other special occasions are often observed with family celebrations, complete with cake, ice cream, and friends. Marie (Matthes) Marx, born in 1838 in Germany, celebrated her 90th birthday in Wisner. At her side is her great-granddaughter Mary Lorensen, age four. Marie and husband, Wilhelm Marx, were engaged in farming. (Courtesy of Laura Franchini.)

Ten

CAUSE FOR APPLAUSE
CUMING COUNTY FLOURISHES

Much of life revolves around the ordinary: what people do for a living, what they wear, how they get from place to place, or what they eat. These essential ingredients give life a particularly sweet taste, whether living in the 19th, 20th, or 21st century. The differences of people going about their daily routines are remarkable.

Lois Kaufman grew up in the day when, as she wrote, "We had no bathrooms, no hot water, no central heat, no nothing as far as conveniences go. When it was hot, we suffered. When it was cold we burned wood, cobs, and coal."

Ardis Karlen Bleyhl remembered when coats were made of the skins of muskrat, raccoons, and ponies and blankets were fashioned of buffalo hide, as the prairie—not modern-day department stores—furnished clothing. Ardis felt the labor-saving device that helped the most through the years was running water.

However, if one would have asked Lois Behling Glade, she might argue. "In the wintertime , our house was an automatic dryer in all the rooms of the house. We had string strung from all the doors and windows across the rooms, and that is where the bed sheets and towels were hung. The underwear went onto a little dryer over the furnace register. Long underwear, the overalls, [and] the men's shirts all hung in the house. Man, did we have a lot of humidity."

Don Maack might say that nothing could beat the days of radio, recalling the excitement of the heavyweight match between Joe Lewis and Max Schmeling. Listening to the War of the Worlds and all of its realism, he said, could not be beat.

So, all things considered, perhaps the best days are the ordinary ones we are experiencing now.

Farmhouses and outbuildings come in all sizes and shapes, from dugouts fit for burrowing gophers and frame houses with lean-to kitchens to two-story brick homes and giant Foursquare styles, just to name a few. Young Eunice Bohlig (right) and a friend are seen above visiting outside of the John and Bertha (Spiegelberg) Bohlig home near Wisner. Gus and Anna (Sorensen) Mielke lived in a larger house while farming near Bancroft. Flowering bushes and plants brightened up the landscape when trailing up a picket fence or blooming near a cellar door. (Above, courtesy of Art Nitzsche Jr. and Norma Doescher; below, courtesy of Henry Heller.)

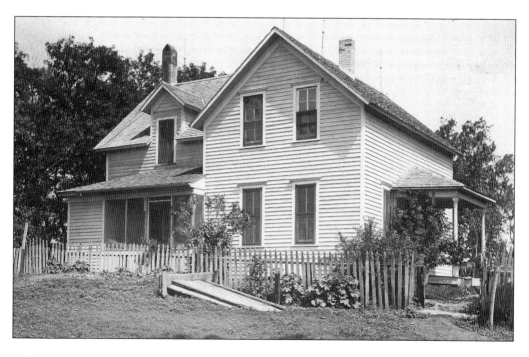

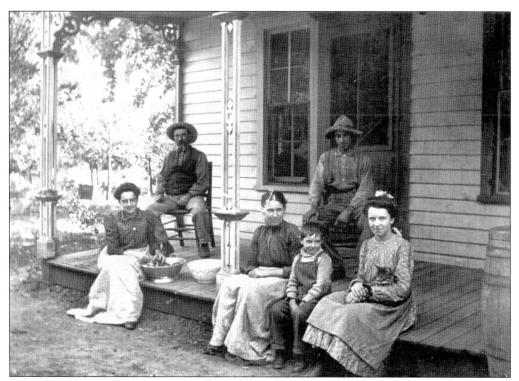

Front porches offered a shady place to pod peas, smoke a pipe, or balance on the porch railing while talking over the week's events. Shown above relaxing on a cool front porch were members the Landis family, West Point residents of the late 1800s. In 1916, the front porch of longtime teacher Emma "Granny" Ward was the perfect place to visit with sons George and twins Clarence and Clement, pictured below. Kitchens became quite warm in the summertime as cookstoves heated water for washing clothes, bathing the baby, cooking meals, canning vegetables, and making soap, all the while simmering a pot of soup. Separate summer kitchens were used on days when temperatures were soaring. (Above, Courtesy of Marjorie Vogt; below, courtesy of John Stahl Library.)

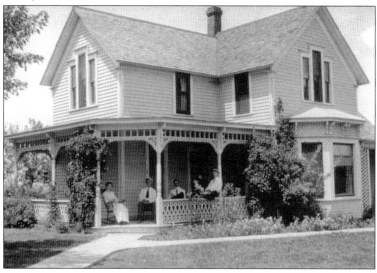

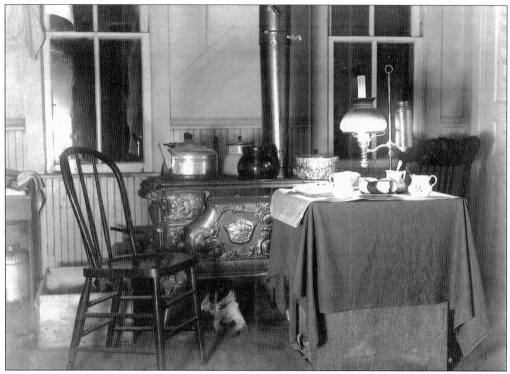

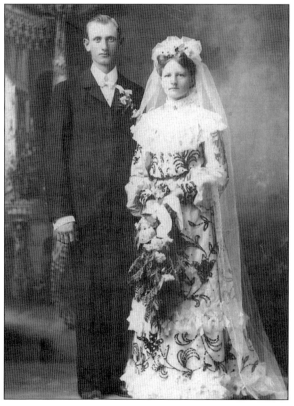

Uriah Bruner, one of West Point's founders, was a private in the Revolutionary War, joining General Washington's forces when they crossed the Delaware River. This scene shows the modern 1890s Bruner kitchen, complete with shiny cookstove, factory-made furniture, and one hunting dog, warming himself under the stove. (Courtesy of John Stahl Library.)

Carl Schultz married Wilhelmine "Minna" Borgelt in 1904 at St. John Lutheran Church in rural Beemer. At the turn of the 20th century, weddings became extravagant as brides chose silk and chiffon fabrics in addition to white satin and lace. After the wedding, brides sometimes removed some of the trimmings to wear the dress once again. (Courtesy of Vernon Schultz.)

Aprons filled many useful purposes. In addition to keeping the dress clean, it was used as a pot holder to lift a hot dish from the cookstove, a basket to gather fresh eggs from the chicken house, and a tissue to wipe a child's nose. From left to right, Emma Baas, Clara Baas, and Agnes (Baas) Nellor, all of West Point, knew the value of an apron. (Courtesy of Sharlene Clatanoff.)

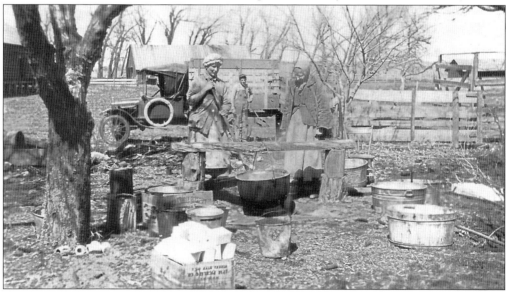

White clothes were sorted from colored clothes, overalls, and rag rugs in the days of a wash boiler and scrub board. The boiler was hung over a fire to heat the water, and clothes were scrubbed clean with homemade lye soap. Marie Harder (left) and Leona Schutte, both of Beemer, are surrounded by tubs of soaking clothes. (Courtesy of Sharlene Clatanoff.)

These two women enjoy the pleasant pastime of swinging in the 1920s. In the back is Irma Wallace, known to many youngsters as "the Cookie Lady." Irma, who taught piano for more than 50 years to around 500 students, distributed a single chocolate banana cookie to each of the youngsters who stopped at the back door of her house. (Courtesy of Marge Holland.)

Between 1913 and 1928, new clothing styles reduced more than 12 yards of cumbersome fabric from women's clothing, fitting well with the independence women gained following World War I. However, in 1930, this newfound self-reliance required they carry a jack, tire pump, and spare inner tube when dealing with a flat tire near West Point. (Courtesy of John Stahl Library.)

Mathilda (Strehle) Ortmeier leans against this vividly painted, wooden Indian outside a cigar shop along West Point's Main Street, one of only two in the entire state in 1925. The tree stump base was believed to have been in place when West Point was founded. A stranger made owner Otto Miller an offer to purchase the Indian several weeks before it was stolen. (Courtesy of John Stahl Library.)

Mona Neihardt, a Bancroft sculptress, fashioned this bust of her husband, John G. Neihardt. While living in Bancroft from 1900 to 1920, as co-owner and editor of the *Bancroft Blade*, Neihardt was able to gather information about the Plains Indians to include in his *Cycle of the West*. He was named Poet Laureate of the State of Nebraska in 1921. (Courtesy of Cuming County Historical Society.)

Eunice (Bohlig) Gentzler Nitzsche grew up on a farm near Wisner in the 1900s. Surrounded by stuffed animals, the little girl had plenty of toys to keep her occupied. Her father, John, saw to it that she had wheels, creating this homemade wheelbarrow to give her rides around the farm. (Courtesy of Art Nitzsche Jr. and Norma Doescher.)

Although the Kodak Brownie box camera was invented in 1900, not every family in Cuming County owned one. To capture a likeness of all family members for posterity, families visited a portrait studio. Ernest and Ottelia (Glaubius) Breitkreutz took their son Orville to such a studio to have his picture taken. Born in 1911 at Wisner, Orville grew up to farm near Wisner. (Courtesy of Marlene Hansen.)

Andrew Oleson built Wisner's first swimming pool in the early 1920s near their home at the top of Twelfth Street. A tent was set up nearby for swimmers to change into their swimsuits. Edith (Leisy) Skinner is shown leading the swimmers, with the barns of the Lorensen farm in the background. (Courtesy of Wisner Heritage Museum.)

It was a proud boy who could bag this many birds by the end of a day's hunt. Otto Kerl, born in 1870, was the son of John and Caroline (Pfeifer) Kerl of West Point. In his warm overcoat and lace-up boots, Otto showed off the ducks brought down by his trusty double-barrel shotgun. (Courtesy of John Stahl Library.)

A boy with a Daisy BB gun, shooting at pigeons, grows up to be a man on a wolf hunt with a Winchester rifle in hand. Lester Gallagher, shown in the photograph above, practiced his aim on the family farm near Beemer, with his faithful dog at his side. Gun clubs often held annual wolf hunts to clear the land of predators, known to skulk around the cattle yard. A specific territory was designated for hunters to begin the hunt, drawing gradually closer until finally, shoulder to shoulder, they met in a final round. Typically, they ended up in a meadow with the wolves trapped in the center. These wolf hunters were photographed at a hunt near West Point. (Above, courtesy of Sharlene Clatanoff; below, courtesy of John Stahl Library.)

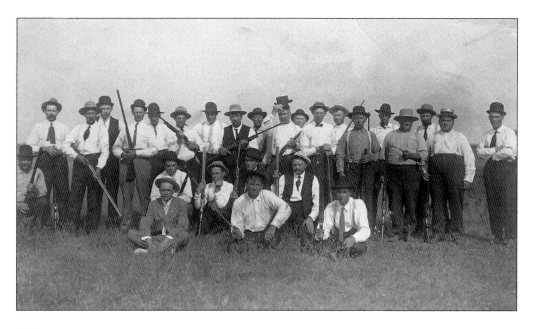

The Elkhorn River offered much in the way of recreation for the people living up and down its banks. In the winter, the frozen surface offered a playing field for ice hockey and a rink for skating. In the summer, swimming and picnicking were favorite pastimes along the river. Carl Zuehr of West Point found the Elkhorn River to be a perfect fishing spot. (Courtesy of John Stahl Library.)

Mother and daughter Louisa and Elsie Koch crossed the Elkhorn River in 1913 with a horse and buggy, returning from a day well spent at Coney Island. The popular amusement park offered a water slide, swimming pool, and harness races, among other delights, sometimes to the background of live music. (Courtesy of John Stahl Library.)

John Baas traveled by team and buggy from his farm home near Beemer in the early 1900s. Note the fly nets worn by the horses. The swishing of the long strings of leather as the horse walked kept the stable flies, mosquitoes, deer flies, and horse flies from biting, subsequently keeping the horse from bucking or bolting. (Courtesy of Sharlene Clatanoff.)

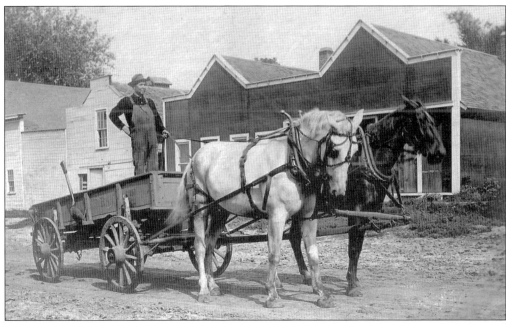

This mismatched team and wooden-wheeled wagon belonged to Mark and Maude (Clayton) Gallagher of Beemer. Mark is pictured in the 1920s in front of the livery stable on the first block west of Beemer's Main Street. (Courtesy of Sharlene Clatanoff.)

Pictured above, Beemerites Carl and Emilie Loewe (left) and Ernest and Bertha Wascher took off for vacation in 1929, with a tent fastened to the side of their Liberty and luggage trapped on the running board. At that time, many travelers were more likely to set up camp than pull into a roadside motel. The Loewes are seen again with friends in the photograph below, stopping to eat on the way to their vacation destination. This scene became an unfamiliar one as fast-food restaurants went up along main highways and interstate systems. The Liberty Six Touring Car was built by the Liberty Motor Car Company at Detroit, Michigan. (Both, courtesy of Norm Kersten.)

Eva (Wallace) Stewart (right) and an unidentified friend reminded travelers to slow down when reaching Wisner's city limits. A 1912 ordinance stated that a person operating a motor vehicle who came upon someone riding or driving a restive horse or other draught animal must bring their vehicle immediately to a stop and remain stationary for a reasonable time to allow such to pass by. (Courtesy of Marge Holland.)

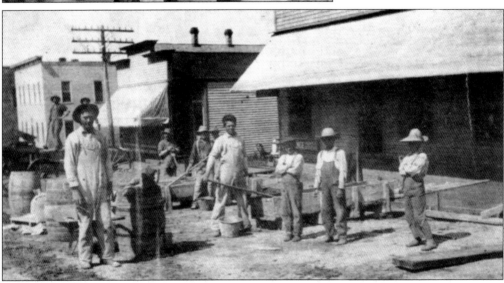

A man and his team earned $1.50 a day mowing weeds on Bancroft city streets in 1887. In 1888, boardwalks were set in place from the train depot to the village's main hub. Wooden boardwalks were replaced by concrete sidewalks in 1904. Hitching posts were removed in 1909 as the large-scale, production-line manufacture of affordable automobiles had begun. (Courtesy of Marjorie Vogt.)

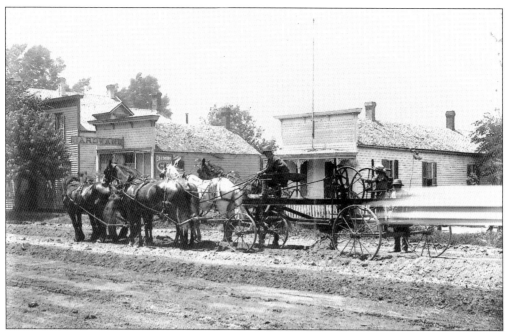

In 1890, this street maintainer was a common sight in West Point. Pulled by three teams, the grader smoothed off the rough spots and broke down clods on dirt-packed city streets. Road grader advertisements of the day spoke of a common-sense road grader, ditcher, and sagebrush cutter. (Courtesy of John Stahl Library.)

Mowing the lawn was a hot task on the best of days but even more so when using a reel mower to do the job. Not powered by an engine or electric motor, the reel mower was powered by the person doing the pushing. When using donkey power, the youngster behind this 1890s mower only had to steer. (Courtesy of John Stahl Library.)

The Neligh House was one of the finest hotels in West Point. Built in 1872, the building stood three stories tall. Its location near the railroad depot provided a steady supply of overnight guests and customers for its restaurant. This photograph of a young boy selling apples is believed to have been taken in the Neligh House lobby. (Courtesy of John Stahl Library.)

Every year, Cuming County communities go out to the streets, allies, and road ditches to pick up fallen sticks and litter. In Bancroft, volunteers were often treated to hot dogs, provided by the city to be enjoyed once the work was done. (Courtesy of Marjorie Vogt.)

Water buckets and volunteers were all it took to form West Point Hook and Ladder Company No. 1 in 1871. Eventually, buckets were traded in for fire hoses wrapped around a fire cart. In time, rural areas also demanded fire protection. Farmers signed petitions calling for the purchase of a rural fire truck, which is sheen here with firemen in 1928. (Courtesy of John Stahl Library.)

A matched team of Angora goats pulled Marvin Blumer through Beemer streets when he was only eight years old. This photograph is believed to have been taken in 1918 in downtown Beemer. Called "the poor man's cow," goats were often trained as pets and harnessed to children's carts. (Courtesy of Gregg Moeller.)

DISCOVER THOUSANDS OF LOCAL HISTORY BOOKS
FEATURING MILLIONS OF VINTAGE IMAGES

Arcadia Publishing, the leading local history publisher in the United States, is committed to making history accessible and meaningful through publishing books that celebrate and preserve the heritage of America's people and places.

Find more books like this at
www.arcadiapublishing.com

Search for your hometown history, your old stomping grounds, and even your favorite sports team.

Consistent with our mission to preserve history on a local level, this book was printed in South Carolina on American-made paper and manufactured entirely in the United States. Products carrying the accredited Forest Stewardship Council (FSC) label are printed on 100 percent FSC-certified paper.

MADE IN THE

USA